Schiele
in
Prison

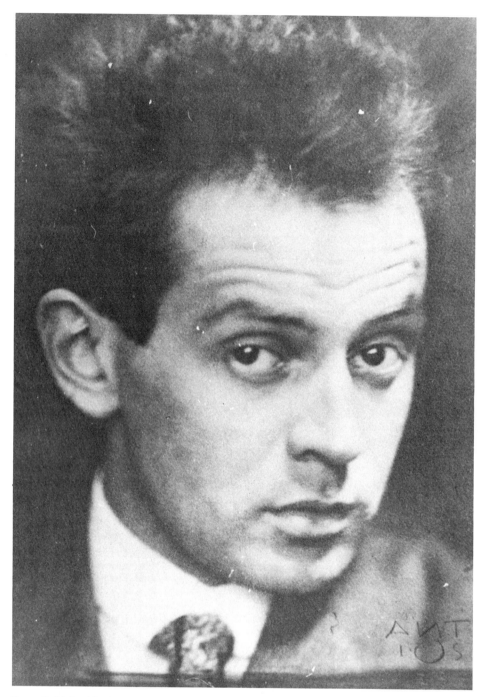

Egon Schiele, 1914

Schiele in Prison

by Alessandra Comini

New York Graphic Society Ltd.

Greenwich, Connecticut

International Standard Book Number 0-8212-0537-4 (hardbound)
International Standard Book Number 0-8212-0554-4 (paperbound)
Library of Congress Catalog Card Number 73-79999

First published 1973 by New York Graphic Society Ltd.
140 Greenwich Ave., Greenwich, Conn. 06830
First printing 1973

Designed by Joseph B. Del Valle

Manufactured in the U.S.A.

TO THE ARTIST'S SISTERS

MELANIE AND GERTI

Table of Contents

Foreword

Ten years ago Alessandra Comini and I discussed those drawings and water-colors by Egon Schiele which are in the Albertina, concentrating in particular on the human and artistic problems inherent in the series that originated during Schiele's imprisonment at Neulengbach in 1912. The young American scholar first published her enlightening ideas on this episode in the artist's life in an article written for the *Albertina Studien.* Her further research into the subject included the memorable moment when she discovered and veri-fied the actual cell in which Schiele was confined, thus allowing a matching-up of various details in the watercolors with the site of the artist's agonizing experience. Now it gives me the greatest pleasure to see that all this material is going to be published in book form. With my congratulations to the author goes my wish for success and the widest possible attention to this book, which for the first time presents a comprehensive interpretation of both Schiele's prison diary and the Neulengbach watercolors.

Walter Koschatzky, *Director*
Graphische Sammlung Albertina
Vienna

"I am the shyest of the shy."

"I am divine."

——Egon Schiele

Chronology of the Artist's Life

1890 Egon, third child of Marie and Adolf Schiele: born on 12 June at Tulln on the Danube, a small town some twenty miles from Vienna, where his father is the railroad stationmaster.

1894 Birth of Schiele's younger sister Gertrud ["Gerti"], with whom he has an intense relationship during their adolescent years.

1896–1900 Attends primary school in Tulln. Spends all his time drawing, to the consternation of his family. His father burns some of the drawings by Egon to punish him for neglecting his schoolwork.

1901–1902 Receives further schooling at the nearby town of Krems.

1902 Moves with his family to Klosterneuburg, near Vienna, where the older sister Melanie takes a job as cashier in the local railroad station to support the family as Adolf Schiele now suffers recurring spells of insanity.

1902–1906 Attends the abbey school of Klosterneuburg. Despite some school comradeship, he remains an outsider, living only for his drawing —an activity still frowned upon by the family.

1904 During the night of 31 December, Schiele's father dies insane. In order to qualify for a larger pension, the family reports the death as occurring 1 January 1905. Leopold Czihaczek, inspector at the North Railroad Station in Vienna and Schiele's uncle by marriage, is appointed the fourteen-year-old boy's legal guardian.

1905 Receives encouragement and private lessons from one of his teachers, the Klosterneuburg painter Ludwig K. Strauch.

1906 Schiele's mother agrees to let him begin studies at the Vienna Academy of Art, despite the objections of Uncle Czihaczek. The family moves to Vienna.

1907 Shows a roll of drawings to Gustav Klimt, who expresses amazement at the boy's extraordinary talent. This praise reinforces Schiele's hostility toward his tradition-bound teachers at the Academy. Notable influence of Klimt's Art Nouveau style and subject matter on Schiele's work from 1907 through 1909.

1908 Participates for the first time in a group exhibition—at Klosterneuburg, where his work is seen by the collector Heinrich Benesch. During this and the next year, makes occasional designs for the *Wiener Werkstätte,* the avant-garde workshop of arts and crafts founded in 1903 by Josef Hoffmann and others.

1909 At the invitation of Klimt, exhibits four paintings in the Vienna *International Kunstschau,* where paintings by Van Gogh are also shown.
Schiele's student days now come to an end as he and a group of colleagues withdraw from the Academy in protest against its conservatism (unwittingly repeating the act performed exactly one hundred years earlier by the Viennese students who later joined the German Nazarenes) and form the *Neukunstgruppe.* Fellow members include Anton (Toni) Faistauer and Schiele's future brother-in-law, Anton Peschka. The group has its first exhibition at the end of the year at the Kunstsalon Pisco, where both Heinrich Benesch and the newspaper critic Arthur Roessler admire Schiele's work.

1910 Casts off the Klimtian Art Nouveau idiom and achieves his own radical Expressionist style—one very close to the more painterly Expressionism of Oskar Kokoschka and Max (Mopp) Oppenheimer. Begins a series of psycho-sexual self-portraits before his mirror; these ultimately will culminate in a row of double self-images. His life is for the most part solitary, and he suffers from poverty in spite of commissions for several important portraits, including one of Arthur Roessler.

1911 Decides to abandon Vienna for rural seclusion at Krumau, his mother's hometown in Bohemia. However, he is pressured to leave there since his maverick conduct and appearance arouse general resentment; this situation repeated toward the end of the year in the village of Neulengbach. Vally (Valerie Neuzil), a model introduced to him by Klimt, shares his small garden house at Krumau and at Neulengbach, inviting further hostility from local villagers.

1912 Paints *The Hermits,* which shows himself and Klimt; this work makes a major statement about Schiele's belief in the special status of the artist. Exhibits in Vienna, Munich, Cologne, and Budapest, but in the midst of increasing professional recognition he suffers a catastrophe in his personal life: on 13 April he is arrested by the Neulengbach police and imprisoned for twenty-four days on charges of "immorality" and "seduction." In prison he keeps a diary and makes at least thirteen watercolors. At his trial one of his previously confiscated drawings is set aflame by the judge; this symbolic condemnation of his art parallels what Schiele's father had done years before. The trauma of Egon's prison experience powerfully affects both his personality and his art. Back in Vienna he becomes a recluse and begins a series of anti-social self-portraits showing himself as monk and hermit. Moves in November to a new studio at Hietzinger Hauptstrasse 101, where he lives until 1918.

1913 Has one-man shows in Munich, Hagen, Stuttgart, and Berlin and exhibits in the Munich and Vienna Secession. Continues his anti-social row of self-portraits and completes several portrait commissions, including *Portrait of Erich Lederer* and *Double Portrait*

of Heinrich and Otto Benesch. Also paints numerous town- and land-scapes; the latter show the influence of the Swiss painter Ferdinand Hodler.

1914 Experiments with etching; contributes drawings to the Berlin avant-garde periodical *Die Aktion.* His sister Gertrud marries his colleague and best friend Anton Peschka. By flapping self-portraits out the window, Schiele provokes acquaintance with Adele and Edith Harms, who live across the street at Hietzinger Hauptstrasse 114. He begins a lively courtship of Edith.

1915 After several previous rejections, is drafted into the Austrian army on 31 May. On 17 June he marries Edith Harms, who then accompanies him to Prague, where he reports for military duty. Edith and Vally refuse to "share" Egon, as he had proposed. Another double self-portrait, *Soaring,* expresses the two directions in which he feels himself drawn. Paints the ghoulish *Death and Maiden* (a farewell to Vally) and a standing portrait of his wife. Shows in Vienna and Zurich.

1916 Manages to get assigned to guard duty, owing to fragile health; is then sent to the village of Mühling, where he sketches army comrades and Russian prisoners of war. Continues to participate in exhibitions abroad. *Die Aktion* features his work in its September issue. Paints portrait of his father-in-law and more land- and city-scapes, including *The Mill.* Plans a double portrait (never executed) of himself and Edith. The double role of soldier and

husband helps to end the self-imposed role of social outcast in both his life and his painted imagery.

1917 Obtains transfer to Vienna and is assigned to the local Army Museum, which enables him to live at home and paint on a regular basis. Begins a new, less radical series of commissioned portraits, including one of the director of the Osterreichische Galerie, Dr. Franz Martin Haberditzl, who soon acquires works by Schiele for the museum. Sends paintings to exhibitions in Amsterdam, Stockholm, Copenhagen, and Munich, but his poverty persists.

1918 Klimt dies on 6 February and Schiele makes three deathbed sketches of him. In March, Schiele's one-man show at the Vienna Secession is a critical and financial success. Commissions increase, and he completes more portraits. On the whole these portraits no longer show the subject tensely posed against an existential void, as in the radical portraits of 1910, but instead picture calmer figures within articulated environments. Owing to the sales of his work Schiele is able to move into a large garden atelier and home at Wattmanngasse 6. Edith becomes pregnant with their first child. In October the terrible influenza epidemic that follows on the heels of World War I reaches Vienna and Edith contracts the disease. During the night of 27 October, Schiele sketches his dying wife—an attempt to stay the hand of death. As her funeral cortege passes below his window a few days later, Schiele is himself confined to bed with influenza; he dies during the night of 31 October.

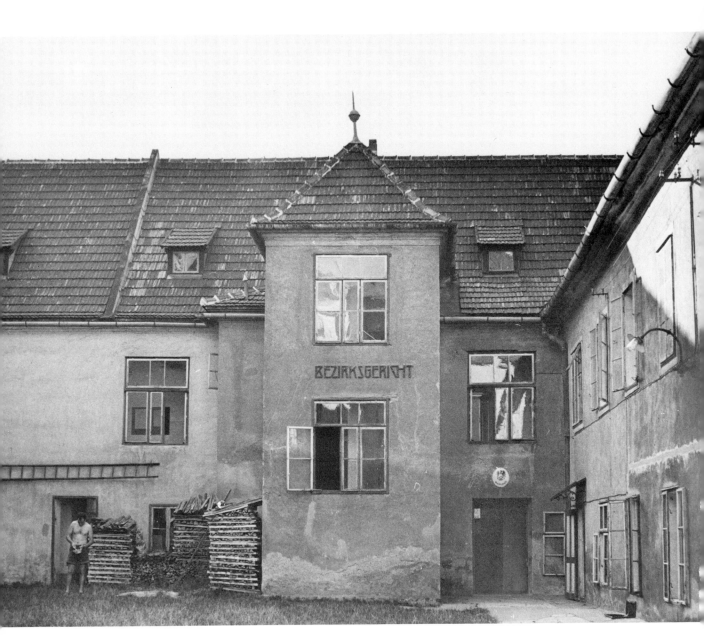

1. The Neulengbach District Courthouse.

Great Expectations

From August 1911 to May 1912 the Austrian village of Neulengbach, some twenty miles from Vienna, played reluctant host to the controversial young Expressionist artist Egon Schiele. The peaceful seclusion of the country town led Schiele into a period of lyrical artistic production and caused him to write his uncle:

> I have come to Neulengbach in order to remain here forever. My intentions are to bring great works to completion, and for this I must work in peace—that was impossible in Vienna. Up to now I have given, and now, because of this, I am so rich that I must give myself away.[1]

Schiele's enthusiasm for the town was not mirrored by the town's enthusiasm for Schiele. The twenty-one-year-old artist's reputation for "pornographic" drawings, the presence of his pretty model Vally, and his invitations to the village children to come and pose for him in the isolated little garden house he had rented on the outskirts of town, aroused first the indignation and then the hostility of the country folk, and at last legal steps were taken to rid Neulengbach of its undesirable inhabitant.

Thus it was that on 13 April 1912 one of the happiest and most creative periods of Schiele's life was brought to a sudden and brutal end. On that day he was arrested by two village constables who also confiscated his

drawings and then locked him up without bond in a basement cell of the Neulengbach district courthouse (fig. 1). The charges against him were "immorality" and "seduction of a minor," but the prisoner apparently was not informed of them for more than a week.[2] The first charge alleged that by careless or willful display of erotic drawings in his studio, while entertaining and sketching child models, Schiele had contributed to their corruption. This accusation came as no surprise to his friends in Vienna, who had often warned the artist to be more judicious about the sort of drawings he left lying around when children came to pose. The second charge could plausibly have been applied to the attractive and vigorous young man, but in this instance, in which a thirteen-year-old celebrity-struck girl was implicated by self-confession, Schiele indignantly insisted in letters and other writings that he was innocent. Whatever the validity of the accusations against Schiele, the charges were sufficient to hold him in prison for twenty-four days, first at Neulengbach during the month of April, and then, sometime after 1 May, at the larger town of St. Pölten.[3] During this time he managed to keep a diary, complete at least thirteen watercolors and one finished drawing, as well as mold a few sculptures out of bread. He was released, after a court trial, on 7 May. At the trial he was assessed a fine and one of his drawings was burned by the judge in symbolic condemnation of his work—an act which Viennese newspapers were to remember for decades (fig. 2). The humiliation of his arrest, imprisonment, and trial left an enduring imprint upon Schiele, affecting both his personal and his artistic development.

Egon Schiele died quite suddenly of influenza at the age of twenty-eight. What sort of person was he, and how does his art fit into the history of modern art? Along with Richard Gerstl (1883–1908) and Oskar Kokoschka (b. 1886), Schiele stands today as one of the most extraordinary representatives of a distinctly Viennese, as opposed to German, Expressionism. A contemporary of Sigmund Freud, Karl Kraus, Adolf Loos, Robert Musil, Arnold Schönberg, George Trakl, Otto Weininger, and Ludwig Wittgenstein, he joined in that collective probing of the psyche which found its first spokesmen in Vienna during the opening decades of the twentieth century. This quest after the essential, this scrutinization of man's inner structure and the meaning of his cultural expressions, was in significant contrast to the widely established, if short-lived, turn-of-the-century movement and mood of Art Nouveau, with its emphasis on the splendid façade, and its message of art for art's sake—a message expressed internationally by the ethereal Loïe Fuller and locally in the exotic, cosmic murals and elegant

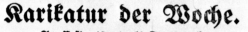

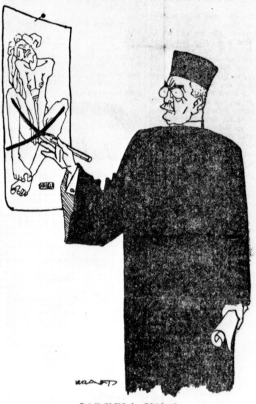

Karikatur der Woche.

Preßstaatsanwalt Formanek

hat auf Grund des Sittlichkeitsparagraphen des Strafgesetzes einen Wiener Buchhändler wegen
der Verbreitung von Egon Schiele-Bildern angeklagt und einen Freispruch erzielt.

Das ist wirklich eine Schweinerei.

2. Caricature of Schiele's work: "This is really filthy!"
Cartoon in unidentified Viennese newspaper
sometime during the 1920's.

female portraits by Gustav Klimt (1862–1918), Vienna's most distinguished
exponent of Art Nouveau. The new exposure of the individual and of society
demanded by Schiele and his contemporaries in art and literature necessi-
tated a corresponding unmasking of the artist's own self, and it was this new
honesty, frequently ruthlessly expressed, which gave rise to the art form
Expressionism. This new style, whether in literature or art, because of its
radical approach and forms, seemed equal to the new psychological task of
art, as a whole generation shifted its attention from the façade to the psyche.

19

3. Schiele, *The Artist and His Model,* 1910, black chalk.

The sheer intensity of this probe is documented in Schiele's self-portrait *The Artist and His Model,* dated 1910 (fig. 3). Working with a concentration that shoots a frown across his forehead, the artist soberly records the data of intricate form and confident eroticism reflected in his mirror. Two features are present in this superb drawing which will frequently recur in Schiele's art: voyeurism and the self. Ultimately Schiele was to direct the white heat of his clinical, relentless voyeurism at his own self, as in his attempts to document before his looking glass the soul-searing effects of masturbation and orgasm. Such concentration is matched by an extraor-

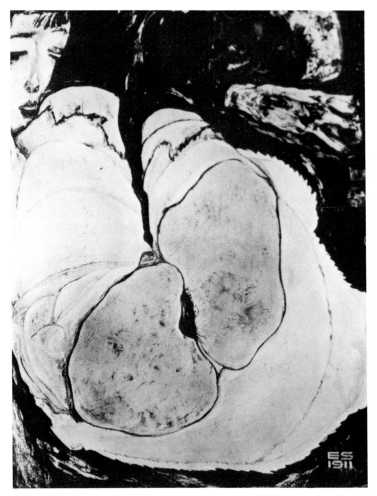

4. Schiele, *Reclining Woman with Upturned Skirt,* 1911, oil.

dinary reduction of form in Schiele's work, and the two together—psycho-
logical intensity and graphic conciseness—are the hallmarks of his art.

There is no doubt that Schiele took pleasure in shocking the public
while at the same time extending the borders of art. Even his most intimate
works, intended for private view only, such as *Reclining Woman with Up-
turned Skirt* (fig. 4), in which the features of his model Vally (Valerie
Neuzil) are recognizable, strove for an explicitness that was almost brutal
in effect. It would be too facile however to characterize Schiele simply as a
public exhibitionist and private voyeur. He tells us himself:

Certainly: I have made pictures which are "horrible"; I do not deny that. But do they believe that I liked to do it or did it in order to act like a "horror of the bouregois"? No! This was never the case. But yearning too has its ghosts. I painted such ghosts. By no means for my pleasure. It was an obligation.[4]

This obligation to which Schiele refers includes a recognition of all aspects of the self, including the psycho-sexual. Like Kraft-Ebing before him, Schiele regarded the findings as phenomenological and revelatory. The fact that he concentrated in his drawings on erotic subject matter, guaranteed to be outrageous, is wholly in keeping with the traditional confrontation of a placid, self-satisfied, bourgeois public and the artist who must erupt through the settled mud of status quo. In Austria particularly, ever since a whole imperial city chose to believe in the Emperor's old clothes rather than acknowledge the presence of an impending and uncontainable social disaster, the compulsion of artists to shock citizens to awareness by conduct that would be termed scandalous or "Spießerschreck," has persisted to the present day —witness the sudden public undressings of Austria's foremost contemporary artist, Fritz Hundertwasser.

Like the querulous Karl Kraus, who incessantly criticized Viennese complacency in his publication *Die Fackel,* Schiele was intentionally abrasive, not only in the content and form of his art, but also in his personal bearing toward friend and stranger alike. And yet there is a bond between the "inner necessity" alluded to by Kandinsky and the Munich Blue Rider group as the moving force in art and that "obligation" admitted to by Schiele in explanation of himself:

Sometimes it tempted me downright irresistibly to appear as a "Spießerschreck," to express in word or action something which I know must have a strange, even repulsive effect on others . . . my outward bearing does not agree with my inner needs.[5]

The dualism expressed here extended to the subject matter of Schiele's paintings throughout his life: on the one hand, obsessive, tortured explorations of all spheres of erotica; on the other, austerely lyrical flowers, trees, town- and land-scapes. Thus at twenty-one, when he traded the intrigues of Vienna for the peace of the small village of Neulengbach, Schiele was both a deliberate public sensation and a genuine recluse. But above and beyond all this, he hoped to bring "great works to completion."

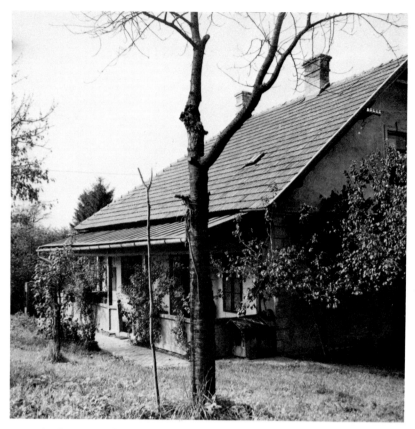

5. Schiele's rented garden house on the outskirts of Neulengbach.

The rustic garden house, Au 48 (fig. 5), which the impecunious Schiele was elated to find at a rent of about $150 a year, stood at the edge of Neulengbach and provided a refuge from the eyes of the villagers, whose curiosity was titillated by the comings and goings in their midst of the strangely dressed artist and his mistress. A photograph of Schiele and Vally dressed up for a promenade—although suggesting a sedate-looking couple to modern eyes —would have attested to their contemporaries in Neulengbach the foppish eccentricity of the artist's clothes and bearing and the no less "foreign" appearance of Vally in her attention-catching "English" suit and broad-brimmed hat (fig. 6). Militantly heedless of the growing hostility around them, Schiele and Vally led a happy and untroubled life together during the first few months in Neulengbach. It did indeed seem that this was a place and time for the creation of "great works." Schiele's spirits rose, and in an expression

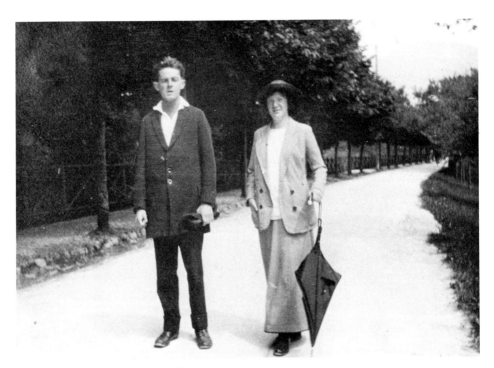

6. Schiele and Valerie Neuzil, 1913.

of affection for his new surroundings he painted, in conscious paraphrase of *Bedroom at Arles* by his idol Van Gogh (fig. 7), a small and cheerfully colored view of his own bedroom at Neulengbach (fig. 8)[6], signing and dating the work three times in a triple affirmation of self. Here we have an interesting case of a picture *within* a picture—both by the same artist. On the upper left wall of Schiele's bedroom, hanging above a low black case containing books and brightly patterned plates, is a black-framed picture by Schiele of a figure pulling up its clothing and exposing a bare torso—quite possibly the very work mentioned by Schiele in his prison diary as seized by the village policemen as "pornographic." In the light of what was to come, this inclusion by Schiele of a "dangerous" picture in a painting documenting the contents of his bedroom confirms his foolhardy attitude. After all, as a subject of the puritanical Emperor Franz Josef, he knew that officialdom could hardly condone erotic works of art. Moreover, friends had advised him not to flaunt such works.

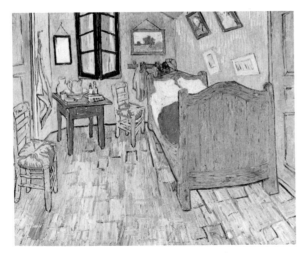

7. Vincent Van Gogh, *Bedroom at Arles,* 1888,
 oil.

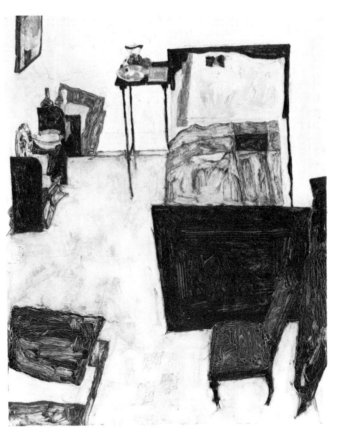

8. Schiele, *The Artist's Bedroom at Neulengbach,* 1911,
 oil.

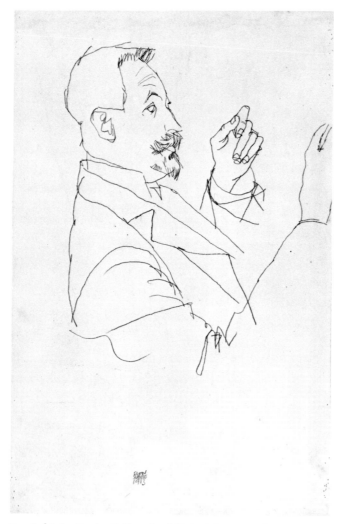

9. Schiele, *Portrait Sketch of Heinrich Benesch,* 1913,
 pencil.

One of these friends, and perhaps the best one the mercurial artist ever had, was *Zentral Inspektor* Heinrich Benesch (fig. 9), an older man who made only a modest living from his position as a railroad inspector in Vienna, but whose enthusiasm for art and art-collecting was to inspire his own son Otto to become an art historian of great breadth and international distinction. Heinrich's first impression of Schiele, whom he met in 1910, bears out the contradictory aspects of the artist as we have seen him so far:

I . . . found a thin young man of more than average height and with an erect, unaffected posture. A pale but not sickly small face, great, dark eyes and luxuriant dark brown hair which stood up from his head in uncontrolled long strands. His manner was a little shy, a little timid, and a little self-conscious. He did not speak much, but when one spoke to him the face was illuminated by the glimmer of a quiet smile. . . . The basic feature of his personality was seriousness, but not a gloomy, melancholy, head-hanging kind. It was rather the quiet seriousness of a man absorbed by a spiritual mission. . . . Schiele's nature was childlike (not childish).[7]

It was Heinrich Benesch who visited Schiele three times during his imprisonment, who alerted his other friends to the fact of his arrest, and who accompanied the discouraged artist back to Vienna after his trial and

10. Schiele, *ca.* 1912–13.

11. Schiele, *Self-Portrait, ca.* 1911–12, pencil.

release, taking care of the shipment of his personal belongings from Neulengbach. The following year, 1913, Schiele expressed his appreciation of Benesch's loyalty by painting a life-size double portrait of father and son (Neue Galerie der Stadt Linz, Wolfgang Gurlitt Museum, Linz). Although, characteristically, Schiele took offense at Heinrich on various occasions, their relationship was far less demanding than the stormy friendship between Schiele and Arthur Roessler. Both of these older men, it should be noted, were father figures, Schiele having lost his own father when only fourteen years old.

12. Schiele, *Portrait of Arthur Roessler,* 1910, oil.

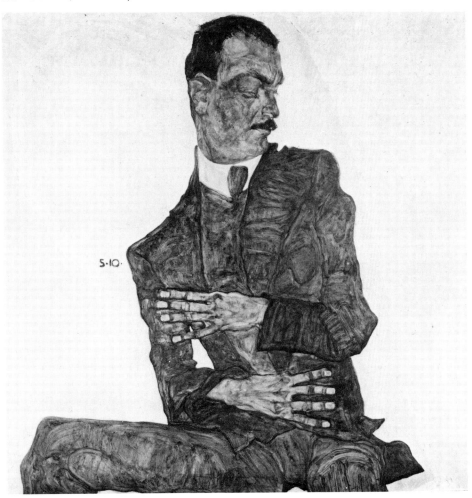

Arthur Roessler (fig. 12) was the art critic for the socialist newspaper *Arbeiter Zeitung*, and his good reviews and publicity on Schiele's behalf were of inestimable value for the young unknown. Fortunately, his first impression of this artist also has been preserved; it rounds out the picture of that "inner necessity" which provoked Schiele's unusual conduct and appearance:

> The impression that I received of Schiele's personality at our first meeting was singular and powerful. . . . It was the impression of having before me a personality extraordinary in its entire character, a personality of such markedly pronounced unusualness that its mere presence might not always be pleasing to everyone, and often not even to itself. . . . Even within a group of well-known men with imposing countenances, Schiele's uncommon appearance stood out, as I was able to observe later on many occasions. He had a tall, slender, supple figure, with narrow shoulders, long arms, and long-fingered, bony hands. His face was beardless and sunburned, and framed by long strands of unruly dark hair. His broad, angular forehead was furrowed by horizontal lines. The mobile features of his face were usually fixed in an earnest, almost sad expression, as though he was suffering from inner, weeping grief. When spoken to, he turned large, dark, astonished eyes—which had first had to chase away the dream that possessed them—upon his interlocutor. His relaxed behavior, never violent with rudeness or impetuous with passionate excitement, the undeniable peculiarity of even the smallest and least expressive of his slow gestures, and his laconic, aphoristic manner of speaking created, in harmonic accordance with his outward appearance, the impression of an inner nobility that was felt even more convincingly since it was obviously natural and in no way intentional.[8]

With this description before us of Schiele as a person who had first to return from a dream world before responding to reality it is intriguing as well as instructive to compare a photograph showing Schiele and Roessler together (fig.13) with the remarkable portrait Schiele painted of Roessler in 1910. It becomes clear immediately that, whereas in life Roessler was a figure of self-confidence and poise—as indicated in the photograph by his assertive stance with arms akimbo—on canvas he was transformed by the

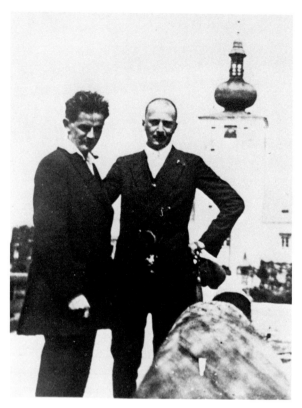

13. Schiele and Arthur Roessler, 1913.

personal alchemy of the artist into a figure dramatically different. The
subject is no longer a man of action, rather a shivering visionary, whose
raised and lowered shoulders shudder as they might in a trance, and whose
enormous hands cross the body in a stiff thumb-concealing gesture that
parallels the tenseness of Schiele's own clenched fist in the photograph. In
other words Schiele had responded to the existential pathos which as an
Expressionist artist he was geared to see in modern man, and he transformed
this practical man of action into the vulnerable dreamer that he himself
was. The poetic disparity between image and reality was fine when it came
to art but was a drawback in regard to Schiele's daily relations with Roess-
ler. Although mutually advantageous, their friendship was punctuated by
jealous misunderstandings and occasional tempestuous arguments. Roessler
was away on vacation in Italy when Schiele was arrested at Neulengbach
and he apparently did not even hear of his friend's imprisonment until after
Schiele was back in Vienna and able to communicate with the outside world

14. Neulengbach prison from the rear, showing Schiele's cell
window (second from the left in bottom row).

again. In a letter to Roessler, he wrote that the pictures he had been allowed
to make in prison would be given only to his closest friends.[9] Heinrich
Benesch received three of the most impressive prison watercolors and
Roessler evidently was entrusted not only with a watercolor but also with
the diary manuscript, which he published as a short book in 1922, four years
after the artist's death.[10]

Before progressing to the text of the diary itself, it is appropriate to
point out the comforting role played by Vally during the days Schiele spent
in prison. Whereas Roessler was completely unaware of the situation, and
Benesch only able to be effective when he left Vienna on week ends either
to visit Schiele or to attempt by personal appeal to dispose the ruling magis-
trate favorably toward the prisoner, Vally, who had been named in the
summons along with her lover, was present in Neulengbach during the entire
imprisonment. She made daily visits—at first not to the cell, since she was

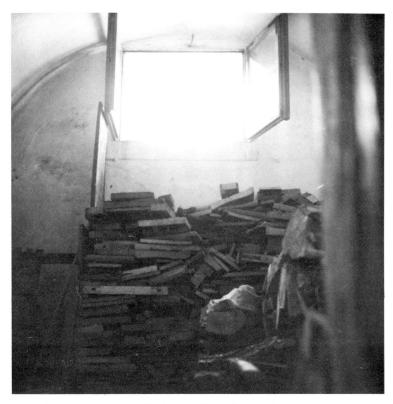

15. Schiele's prison cell window from the inside.

prevented from entering—but to the rear of the prison building, which rose
clifflike above a sudden drop of land, exposing the window of Schiele's
basement cell to her view (fig. 14). Through the thick, close-set iron bars of
this window (fig. 15), Vally attempted—and sometimes succeeded—to throw
fruit, presents, and notes of encouragement to her Egon. Schiele afterward
referred to her behavior at Neulengbach as "noble."

Arrest and confinement in a crude country jail permanently affected
the young artist. To understand their full impact, it helps to look back at a
remarkable letter that Schiele had written shortly after his hopeful arrival
at Neulengbach. Though full of unfinished thoughts, eccentric punctuation,
and difficult syntax, it reveals a human being of extraordinary sensitivity
and one with dazzling confidence in his special status as "artist." At once
proud and humble, the letter can well be considered a manifesto of aesthetic
imperative.

I have become aware: earth breathes, smells, listens, feels in all its little parts; it adds to itself, couples itself, falls to pieces, and finds itself, enjoys what life is, and seeks the logical philosophy of all, all in all; days and years of all transitoriness, as far as one wishes and is able to think, as far as the spirit of beings possesses great contents; through our air, our light. It [the earth] has become some thing or many things, even to creators—who are necessary—and has partially perished, consumed in itself, back into itself again, and begins the smaller or greater cycle. Everything that I want to call divine germinates anew and brings forth and creates, out of a power which few see, a creature.

The transitoriness of the material is determined in the sense of an existence; a sure becoming and passing away, a coming—life, in which concept one should understand that there is endless disintegration which, however, can be kept vital through organic means. Yes, it [life] can become retroactive, far back, so that it, by these means, can bestow no complete death.

There was, is, and will be the old or the new primal spirit, which has wants, which out of something—out of unions, out of interminglings—must bring forth, must create; the real great Mother of all, of everything similar but still separate, who wills (thus was, is, and will be the wish) always to be able to create out of these our eternal means the most manifold human beings, animals, plants, living creatures in general. As soon as this physics is present, just so soon does the common will of the world exist.

I possess immediate means within myself which can draw, in order to record, can wish to fathom, to invent, to discover—means within myself which already have the great power to kindle themselves, to burn themselves up and to shine like a thought out of the eternal light, and to glow into the darkest eternities of our little world, which consists of only so few elements.

All disguises for us are, anyway, for naught, since they conceal us, instead of having the urge to interweave with other organs.

When I see myself completely, I shall *have* to see myself, and will *have* to know what I want, not only what enters within myself, but also how far I have the ability to see what means are mine, out of what puzzling substances I am made, out of how much of the more, what I recognize, what I have so far recognized within myself.

I see myself evaporate and breathe forth more and more strongly; the oscillations of my astral light become swifter, sharper, simpler, and like a great recognition of the world.

So I bring forth out of myself always more, always something further, an endlessly brighter shining, as far as love, which is everything, enriches me in this way and leads me to this to which I am instinctively drawn; which I want to tear into myself so that I may create again a new thing which I, in spite of myself, have perceived.

My existence, my decay, transposed to enduring values, must sooner or later bring my strength to other strongly or more strongly developed beings—like an enlightening religious revelation.

The farthest away will notice me, the more distant ones will look at me, and my negative ones [enemies] will live by my hypnosis!

I am so rich that I must give myself away.[11]

Notes

1. Letter dated 1 September 1911, addressed to O. C. ("Onkel" Czihaczek), possession Gertrud Peschka and Anton Peschka, Jr., Vienna. I am indebted to Schiele's younger sister, Frau Gertrud Peschka, and nephew, Herr Anton Peschka, Jr., for bringing this letter to my attention.

2. Actually the summons had been issued on 11 April, but the diary specifically mentions the thirteenth as the actual day of arrest (see entry for 17 April). The town school of Neulengbach was just being completed that year and civic awareness—the proper education of the town's children versus their exposure to the bohemian artist in the village—must have been keen.

3. No record of Schiele's trial now exists at the St. Pölten courthouse, which, unfortunately for historians, has a policy of destroying all documents more than thirty years old.

4. Arthur Roessler, *Erinnerungen an Egon Schiele* (2nd ed., Vienna, 1948), p. 40. Translation of this, and all other passages cited, mine.

5. Roessler, *Erinnerungen an Egon Schiele*, pp. 39–40.

6. Schiele knew Van Gogh's *Bedroom at Arles* (de La Faille No. 484) from firsthand observation: he had seen it on exhibit at the 1909 *International Kunstschau* in Vienna, where his own works were also on exhibit, and he was later able to study it in the home of its owner, the Viennese collector Carl Reininghaus—patron and friend of both Schiele and Kokoschka.

Schiele's older sister, Melanie Schuster, recalls that Schiele was fond of pointing out the fact that Van Gogh had died in 1890, the year of his own birth. For the young Austrian artist this coincidence clinched the spiritual kinship he felt for the Dutch painter. I am grateful to Frau Melanie Schuster of Vienna for the many interviews she has granted me over the past decade concerning her brother.

7. Heinrich Benesch, handwritten essay entitled "Mein Weg mit Egon Schiele," dated November 1943, in an album of reminiscences compiled by Max Wagner titled "Egon Schiele Erinnerungsbuch" (pages not numbered) in the Egon Schiele Archive of the Graphische Sammlung Albertina, Vienna. My thanks go to Dr. Walter Koschatzky, director of the Albertina, for allowing me to study in detail the rich material contained in the Egon Schiele Archive. A slightly expurgated version of the essay by Heinrich Benesch was published in book form, and under the same title, by Dr. Otto Kallir (New York, 1965).

8. Roessler, *Erinnerungen an Egon Schiele*, pp. 5–6.

9. Roessler, *Briefe und Prosa von Egon Schiele* (Vienna, 1921), pp. 66–67.

10. A vigorous attempt on my part to examine the original manuscript from which Roessler published the diary has proved fruitless. The circumstances surrounding its removal from the rest of the Roessler estate that went into the Historisches Museum der Stadt Wien apparently do not yet

permit admission of the manuscript into the public domain. Judging from Roessler's "editing" of Schiele's war diary of 1916, the original of which is in the Egon Schiele Archive of the Albertina, and a transcription of which I published in the *Albertina Studien* (IV, 2, 1966), I feel obligated to suggest that Roessler may have tampered with the diary, even perhaps to the extent of having changed or suppressed certain entries. For instance, considering that Heinrich Benesch was able to visit Schiele three times while he was in jail, I find it most peculiar that there is no mention of these encounters in the diary. Given the demonstrable possessiveness which Roessler felt for his young protégé, it is quite likely, in my opinion, that Roessler simply edited out any references to Benesch's visits, for from whom other than Benesch could Schiele have learned the information recorded on 24 April that Klimt was away at Attersee and Roessler at Lake Garda? It might perhaps have been Vally who passed this information on to Schiele, but since it was Heinrich Benesch who, with the greatest concern, informed all Schiele's Vienna friends of his arrest and tried to obtain aid from them, and since he managed to visit the artist within the first fourteen days of his arrest (see letter from Dr. Oskar Reichel to Arthur Roessler, dated 2 May 1912, Stadtbibliothek, Vienna, Inv. No. 147035), it seems more probable that it was Benesch who brought with him the latest reports on the whereabouts of their mutual friends.

All this makes the diary entry of 28 April a bit suspect. "Of all my friends A. R. loves me the most strongly and the most purely because he understands me the most deeply, with his heart." One wonders if perhaps originally the initials might not have been "H. B." This suspicion tends to be strengthened by the fact that a letter written by Schiele to Franz Hauer on 25 January 1914 recalls the Neulengbach crisis with the following specific reference to Heinrich Benesch: "Of those who knew me best nobody made a move except Vally, whom I had known only a short time and who acted so nobly that she captivated [me], and Herr Benesch." (Letter possession Historisches Museum der Stadt Wien, Vienna; transcription kindly provided me by the recently retired director of the museum, Dr. Franz Glück.)

On the other hand it could be argued that Heinrich Benesch, who lived into the 1940's, had adequate time to object if he found anything amiss in Roessler's editing. It is obvious that a definitive edition of Schiele's prison diary can only be assured when the diary manuscript is released into the public domain.

11. Roessler, *Briefe und Prosa von Egon Schiele* (Vienna, 1921), pp. 145–46. The letter is difficult to translate faithfully into readable English, and I wish to acknowledge the aid of all those who, over the years, have advised me concerning this and other recondite Schiele passages: Hildegard Bachert, Prof. Joseph Bauke, Prof. Megan Laird Comini, Prof. Emeritus Julius Held, Prof. Walter Horn, Dr. Otto Kallir, the late Dr. Max Mell, and Serge and Vally Sabarsky. I owe a special debt of gratitude to Horst Uhr for his careful and patient reworking of the translation of the prison diary.

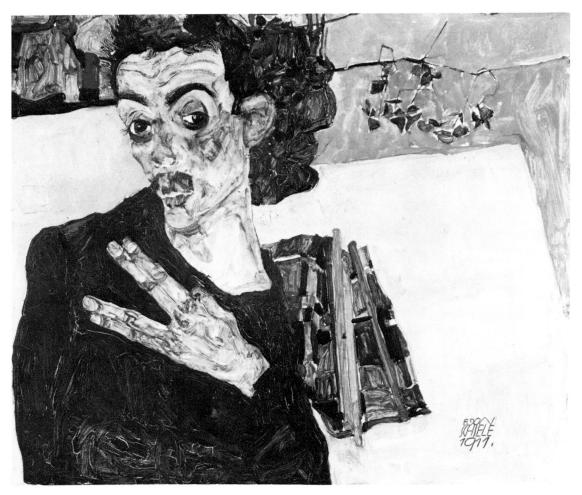

16. Schiele, *Self-Portrait with Fingers Spread Apart*, 1911, oil.

Schiele
in
Prison

Foreword by Arthur Roessler to First Publication of Schiele's Prison Diary, Vienna, 1922

From Vienna on 9 May 1912, Egon Schiele wrote me at Tarbole on Lake Garda; he was in a state of the most painful inner disorientation: "... I am wretched, I tell you, innerly so wretched! For twenty-four days I was under arrest. Do you know nothing about it? Have experienced everything and will write you in detail about it soon."

The following pages contain the verbal and sketched account of the experiences of those twenty-four days. The time that has passed since then and the death of the artist make Schiele's arrest sufficiently remote that it now appears as that which, in reality, it always was: the ill-intended blunder of overly enthusiastic moral busybodies and the pitiful martyrdom of an artist who was misunderstood in his lifetime.

Schiele saw himself forced to tread paths completely overgrown with the weeds of prejudice. If a spontaneous scheme did sometimes open before him, he discovered all too soon that deceitful delights also exist, that morasses, too, are carpeted with blossoming flowers. For Egon Schiele's life as a fellow human among humans, the dry words of Sister Hadwiga hold true: "Thus, being human, so live also in misery as a human."

NOTE: Roessler's 1922 German edition of Schiele's prison dairy has been the basis for the English translation of the diary presented in this book.

Egon Schiele's
Prison Diary

Neulengbach Prison, 16 April 1912

At last! At last! At last! At last alleviation of pain! At last paper, pencils, brush, colors for drawing and writing. Excruciating were those wild, confused, crude, those unchanging, unformed, monotonously gray, gray hours which I had to pass—robbed, naked, between cold, bare walls—like an animal.

It would quickly have led to madness for those who are innerly weak; and soon I too would have gone mad, had this stupefaction, day in day out, lasted any longer. And thus I, as I am, torn with my roots from the soil of my activity, in order not to go really mad painted—with trembling fingers dipped in bitter spit. Using the stains in the plaster I painted landscapes and heads on the walls of the cell. And then I watched as little by little they dried up, faded and disappeared into the depths of the masonry, as if wiped out by an invisible, magically powerful hand.

41

Now, fortunately, I again have materials for drawing and writing; even the dangerous little penknife has been returned to me. I can be busy, and so I will endure what otherwise would be unendurable. I humbled myself, lowered myself; I requested, entreated, begged for this, and would have whimpered, if there had been no other way. Oh, art! What would I not take upon myself for you!

17 April 1912

Thirteenth, thirteenth, thirteenth—thirteen times the thirteenth of April! I have never thought of the thirteenth superstitiously, fearfully, and yet now a thirteenth day of the month has become calamitous for me. For on 13 April 1912 I was arrested and put under lock and key in the Neulengbach district courthouse.

Why? Why? Why?

I do not know. To my question no answer was given.

No cry shouting about my arrest sounds through Vienna—because no one knows yet that I have been overpowered and have disappeared as though through a trap door. And if it were known—would there be an outcry? Would anyone help? G. K. and A. R. perhaps; others, however, would sneak off in cowardice, and T. F. would be Jesuitic, with impassive face and unblinking eyes.* He would shrug his shoulders and fancy himself freed from one who stood in the way.

* Initials refer to Gustav Klimt, Arthur Roessler, and Anton ("Toni") Faistauer.

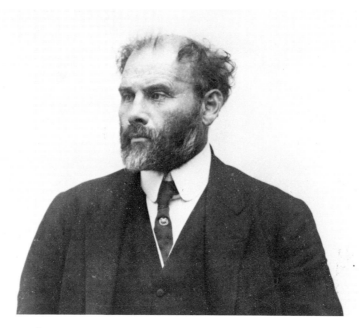

17. Gustav Klimt, sometime during World War I.

Hell! A hell, not <u>the</u> hell, but a base, vulgar, dirty, miserable, shaming hell is this into which I have been thrown unexpectedly.

Dust, spider webs, cough spit, sediment of sweat, also tears have sprinkled the scurfy, crumbling plaster of this room. Where the bunk touches the wall the stains are the thickest and the limy whitewash has been rubbed off. As though polished, the bricks are like blood smears, all smooth and with a dark fatty shine.

I know now what a dungeon is—it looks like a dungeon here. If one observes the thick, rough, heavy door, with the big secure lock that can not be broken by a shoulder's nudge or a kick—the key-hole with a cover, the clumsily put together bench or bunk made of crude posts, its rough, lumpy blanket (a horse's back would

cringe at being covered with it) which stinks strangely of carbolic acid or lysol and human sweat and musty wetness and animal's wool—when one has observed all this one has experienced the dungeon of olden times, the chamber of horrors of an old fortress, of an old city hall into which prisoners were thrown and where they rotted.

Only the button for the electric bell above the head of the bed does not belong, it is present-day, is modern. And so I know that I am not dreaming, am not seeing visions. No, I am not dreaming. I live, experience—unless all life is just a dream in which there are nightmares.

18 April 1912

I must live in my own excrement, breathe in my own poisonous, sticky fumes. I am unshaven—I can not even wash myself properly. Yet I am a human being! I still am, although imprisoned. Does no one think of that?

The key-jangling guard put a bucket, broom, brush, etc. in the cell and ordered me to scrub the floor. Is that allowed? Indecent, this demand. And yet I was happy about it; just to be busy is a blessing. I scrubbed and scoured, washed and wiped with all my strength. Knees, spine, and arms still hurt long afterwards and my fingers are raw, the nails broken. Almost proud of what I had done, I waited for the guard and believed that he would praise me. He came, looked at the floor, then spat, here and there he spat, ugly puddles, and growled: "D'you call this scrubbed? It's nothin' but pig's smear. Scrub it again, right away, but good this time I'm tellin' you!" And I dragged water over and knelt down again and scrubbed and scrubbed.

How can people find joy (Joy! Thou source of light immortal!) in humiliating others so? From whence this evil desire?

How is this vileness possible? After all, I have not been sentenced! Why should it be that they want to punish me so?

No one here knows yet whether I am innocent or not—and if I am, how can they treat me so badly? Do they do this with all prisoners under surveillance? It would be good for once to lock up all deputies for no reason, as with me, so that the thoughtless lawmakers could experience and understand through their own bodies (since they do not have a soul or only a stunted one) what it means to be imprisoned.

19 April 1912

I have painted the cot in my cell. In the middle of the dirty gray of the blankets a glowing orange, which V. brought me, as the single shining light in the room. The little colorful spot did me unspeakable good.

20 April 1912

Drew the corridor before the cells, with the rubbish that lies in the corners and the equipment used by the prisoners to clean their cells. Fine. Gave me equilibrium. I feel not punished but purified!

The imprisonment has become more bearable since I have been able to work. I have drawn the organic movement of the primitive chair and water pitcher, and lightly applied colors to the drawing. I also drew two of my colored handkerchiefs in combination with the chair.

22 April 1912

Primordially eternal is God. Man calls him Buddha, Zoroaster, Osiris, Zeus, or Christ, and timeless like God is that which is most Godlike after him, art. Art can not be modern; art is primordially eternal.

23 April 1912

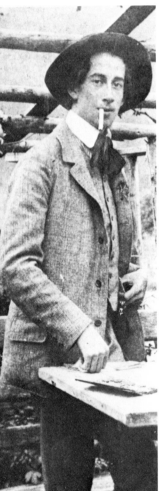

Look down here, universal Father, creator of all, sun-eyed great one that you are, everywhere and also here, and consider whether you wish to tolerate that this shameful, debasing torture is being prepared for me. Your penetrating glances have shown through my most hidden recesses, you have knowledge of me, I am naked before you and completely recognizable as your creature. Thus when I stumble it is with your will that I stumble on your paths. But to suffer through your will? To be imprisoned through your will? Am I? Perhaps, only for a second, you have closed your kind,

18. Anton ("Toni") Faistauer, 1905.

sea-sky-blue eyes before the silver glittering shine of your circling worlds of stars or before the fire-sparked wheel of your golden, melting sun, and thus have forgotten me? It could be. This is why I call to you: hear me, lend me your unlocked ear!

24 April 1912

Not very far from me, so near that he would have to hear my voice if I were to shout, there sits in his magistrate's office a judge, or whatever he is. A man, that is, who believes that he is something special, who has studied, who has lived in the city, who has visited churches, museums, theaters, concerts, yes, probably even art exhibitions. A man who consequently is numbered among the educated class which has read or at least heard of the life of the artist. And this man can permit me to be locked up in a cage! Hours, yes, days, he leaves me in here and does not bother himself about me at all. What is he thinking? What kind of conscience does the man have?

Perhaps he has worries, perhaps he is indifferent, perhaps he forgets me! Perhaps I have to spend months in prison; yes, perhaps I will become sick and die here before my innocence is established.

No help is in sight—no friend within reach. I can inform no one. K. is at Attersee, R. is at Lake Garda—who knows where the others are? But even if they were in Vienna, no one could free me immediately since I am forbidden to write anyone.

25 April 1912

Yesterday: cries—soft, timid, wailing; screams—loud, urgent, imploring; groaning sobs—desperate, fearfully desperate. Finally apathetic stretching out with cold limbs, deathly afraid, bathed in shivering sweat. And yet, for my art and for my loved ones I will gladly endure to the end.

27 April 1912

What would I do now if I did not have art? How horrible the uncomprehended hours were—to be brutally torn from eternal dreams where nothing ugly exists, only the astonishing, and to feel pulled into senseless crudity that lacks everything that beautifies crudity —which can also be strength.

I love life. I love to sink into the depths of all living beings; but I abhor that force which like an enemy enchains me and wants to compel me to a life, not my own, that is of base use, of base purpose, without art—without God.

28 April 1912

Of all my friends A. R. loves me the most strongly and the most purely because he understands me the most deeply, with his heart. One understands when one loves, and one should always love when one understands.

If only I knew why they have stuck me in here. It could not have happened because of the drawing. Or could it? In Austria anything is possible. Here, where Waldmüller* had to write the tax office a beggar's letter, where Romako** was driven to suicide by the lack of understanding and the jealous envy of incompetents, where university professors sneered at Klimt in the most shameful, self-tainting way.

But what does it all matter! Captive, captive, I am locked up—can not stir, may do nothing—and outside it is spring, the dark, moist earth is fragrant, the sap is rising, the first flowers are blooming! I would like to hike, to walk to the bright flowered fields of grass and under blossoming bushes listen to the singing of small, loving birds with shining eyes, like set jewels or drops of colored enamel.

1 May 1912

I dreamt of Trieste, of the sea, of open space. Longing, oh, longing! For comfort I painted myself a ship, colorful and big-bellied, like those that rock back and forth on the Adriatic. In it longing and phantasy can sail over the sea, far out to distant islands where jewel-like birds glide and sing among incredible trees. Oh, sea?

* Ferdinand Waldmüller (1793–1865). An artist associated with Biedermeier realism; especially prolific in portraiture and landscapes. Belatedly, one of Austria's most beloved painters.
** Anton Romako (1834–89). Isolated from the mainstream of Biedermeier realism, Romako's loose, glittering history scenes and his often intense portraiture formed an important bridge between the bravura of Austrian baroque and the psychological emphasis of Viennese Expressionism.

Interruption, change. I have been transferred to the prison of St. Pölten.

The constable was very friendly. A good fellow. He did not tie me. I was even allowed to smoke secretly.

But the most beautiful part was the train ride. I could imagine that I was on a trip. I looked out the window and saw how the fields unfolded as the train passed. It was a slow-going train, which pleased me this time, because I wanted to see a great deal and for a long time. I saw beautiful things: sky, clouds, flying birds, grainy trees, and quiet houses with cushion-soft roofs.

Some day.

How long is it now that I have been part of the limy walls made leprous by the misery of mankind?

How long is it now that I have smelled no cradling white winds over swaying greenery?

How long is it now that I have seen no soft cotton clouds, no dewy mornings, no blue twilight evenings, only black, black nights?

Does the sun still roll its sparkling giant gold disc in a high arc over the trembling earth?

Around me all colors are extinguished. It is frightening. The place of the damned must be this colorless. A glowing, fiery hell would still be beautiful! And since all that is beautiful confers happiness and blesses, a flaming hell would be no punishment—only the gray, gray, gray which is part of the endless monotony and wilderness is the true, terrible, satanic punishment.

How long have I been a prisoner? I, by nature, one of the freest, bound only to the law which is not that of the masses.

Much, much time—an eternity has gone by. Time is variable in length. Time can linger and time can hurry; it is a concept and varies really according to circumstances.

Another day, a May day!

A walk in the prison courtyard. Roller is surely a great artist, but his prison yard in <u>Fidelio</u> is still only theater, whereas the painting of the prison courtyard by Van Gogh is the most stirring truth, great art.

Trot, trot, around in a circle. How absurd, always one behind the other. An hour at a time. In the stinking present moment this ring of trotting men has a less tragic effect than I expected.

I was stared at curiously by my prison mates and I looked back at them with astonishment. They talked to me from all sides. At first I did not understand the spat, hissed, gurgled words—spoken from the belly—these were the whispered expressions of thieves' and pimps' language. Little by little, however, I gathered what these fellows wanted to know: they wanted to know why I had been "buried," that is, arrested. I said I did not know. At this they twisted up their faces maliciously and grinned contemptuously. Actually even these degenerates still have some contempt left over for others. Most of them also asked if I had a "Tschik"—a cigarette butt to smoke or chew—for them. I had nothing of the kind any more. One, a red-haired fellow with water-green eyes, pointed at my American shoes. He absolutely wanted me to give them to him in exchange for something from him.

An older man, a real underworld type, maneuvered very cleverly to get near me. Almost unnoticeably he kept pushing himself ahead of others until, shambling along directly behind me, he was creeping at my heels. He asked questions which I did not answer because I did not understand them. He also asked what I was. I told him. At this he snickered hoarsely and then whispered something to the man behind him, who then laughed. The laughter, a suppressed, dull laughter, went on through the entire ring of men walking in a circle until it ended with the man in front of me, who doubled over with laughter. He turned his head back, bared his teeth, licked his blue-red lips with his thick, swollen tongue and said: "You seduced a girl, right?"

In a flash it went through me: his suspicion might be the suspicion of the court. Maybe there is a connection between my arrest and the supposed abduction of the strange girl who by now is surely back with her family or her grandmother again. After this occurred to me I felt relieved, calmed. I know that nothing can happen to me in this connection, that the "abduction" will have to be clarified as a misunderstanding because there was no abduction at all. The business with the strange girl happened more like this:

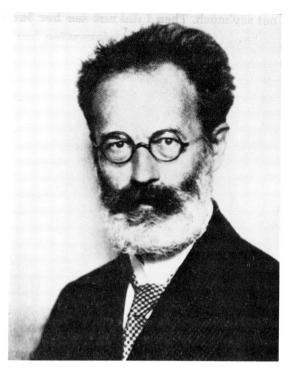

19. Alfred Roller, *ca.* 1904.

As soon as the weather permitted I began working in Neulengbach outdoors, at first in the garden of my house, but then farther off wherever something interested me at the moment. It was then that the strolling young lady saw me. She was shy and watched at first only from a distance, but one day she came over, stopped, and watched me while I worked. She was holding a catalogue from the Künstlerhaus in her hand, and in such a way that I had to notice. I paid no attention to it. Then she asked me if I too would exhibit in the Künstlerhaus. It was stupid of her, but I did not wish to hurt her feelings and answered only that I am an irreconcilable opponent of the Künstlerhaus because they are painters in name only, etc. She listened to me in silence, then thanked me for the explanation and left. In this way she approached me a few more times when I was working outdoors, but since she asked stupid questions and also had no instinct for the essence of art or for artistic creation, conversing with her was no pleasure for me and

I did not say much. Then I did not see her for some time. All of a sudden, however—I had almost forgotten her already—late in the evening during some bad weather—storm and rain—my doorbell rang. V. was with me and we were very curious to see who would be coming in such miserable weather and at such a late hour from Vienna, since we had no acquaintances in Neulengbach. I opened the door and saw the young lady, all wet and muddy from the dirty country roads. She was pale and very excited. I led her into the room, which was heated because I had drawn a nude model that day, and introduced her to V., who did not appear too happy. Without my asking, the girl started to rant on about fleeing to me because she could no longer bear to live in her parents' home. She began to cry and protested that she was misunderstood by her people, tortured, fenced in; in short, all possible unpleasantness was inflicted upon her so that she simply could no longer bear it and would rather flee into the wide world and to strangers, or even die, than stay home. This was very embarrassing for me, yet I could not say anything because I could not and would not hurt or reject the unhappy girl.

At that point V. helped, making it clear to the visitor that it was impossible for her to stay with us, not because we did not want to help or keep her, but because we could not help her since in a day or so she would be taken by force from my house by her parents and in this gossip's nest the whole thing would end in a huge scandal.

At first the weeping girl only continued to shake her head, but then after discarding her suspicions of V. she seemed to realize that V. was right. She said that she wanted to go to her grandmother in Vienna on the following morning and begged us to keep her in the house at least for this one night, since she would under no circumstances return to her parents.

What should I do? The weather had gotten consistently worse, the storm was raging around the house, which stood relatively unprotected, the rain smacked sheets of water against the rattling windowpanes, in the chimney flue the wind whimpered and howled, and outside it was pitch dark and cold. And so I told the girl, freezing pitifully in her wet clothes, that she could stay and sleep with V. She tried to kiss my hand for this, which I, of course, did not allow. V. then went with her into another room so she could put on something dry. We ate together, drank beer and smoked, sat for a while and talked about all kinds of things, and then the two girls went to sleep. I stayed alone and thought things over.

The next morning we three traveled to Vienna. At the West Railroad Station I said good-by to the two. V. went with the stranger to accompany her to her grandmother's, where after all she was afraid to go alone. I had arranged to meet V. the next day at a specific train in the West Railroad Station because I wanted to take her with me to Neulengbach to model again. As I came up to the train in the station, I did not believe my eyes as I saw the young lady standing there with V. She said that she had not dared to go to her grandmother's after all, therefore had spent the night in a hotel with V., and that now she would return again to Neulengbach. I had no objections to raise to this plan, for I believed, naturally enough, that she meant by this that she was returning to her parents. Even when she returned to our house with us in Neulengbach and stayed there, I still did not think it was curious because I thought she did not dare go home before dark. But it was already uncomfortable for me that she stayed with me so long. However, I said nothing about it, I do not know why not. And so, she stayed until nighttime and again overnight. I decided to speak to V. after the girl had gone to sleep. I then arranged with V. that the next morning she make clear to the stranger the impossibility of her staying any longer and that she must take her back to her parents. Something quite different developed.

The following morning I was standing at my easel and painting. The girl suddenly cried, "My father is coming, oh, God!" And she was right. As I looked out I saw an elderly gentleman coming through the garden to the house. I did not wait for his ring, but went to meet him. We greeted each other politely at the door and he said that he knew—that he had heard from people who had seen her—that his daughter was with me and that therefore I should bring the girl out immediately, since I would otherwise come into conflict with the court for seduction of a minor, that he had already filed a complaint, etc. To this I very quietly explained that first of all there could be no talk of seduction, for his daughter, whom I knew only superficially and in whom I did not have any further interest at all, came to me on a stormy night in voluntary flight from her parent's home, etc., and begged me for a night's lodging. I told him that nothing happened to her in my house and that she had spent the night with V., who, by the way, had been present the whole time. "Where, then, is my daughter?", asked the father. I said: "Here in the next room," and pointed to the door.

At that moment there sounded a cry, then a crash. We ran into the next room and saw the girl lying on the floor with my large paper-cutting shears in her hand. In her fear of her father the stupid thing had tried to puncture the arteries in her wrists. Fortunately she was unsuccessful in this. Either the scissors were too dull, the force applied too slight, the girl too clumsy, or she merely acted as though she wanted to do it. After a little excitement both father and daughter left, reconciled, it seemed to me, with each other. I was glad and considered the matter settled.

That seems to have been an illusion. In his happiness over finding his daughter again the father apparently forgot to retract as false the complaint concerning the supposed seduction and now, although innocent, I have to suffer for it. I will demand to be presented to the examining judge—it must be some higher official—

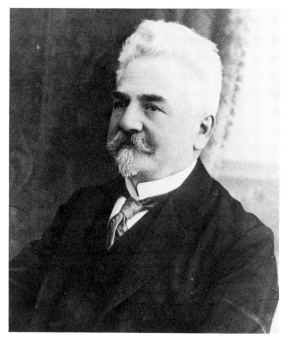

20. Schiele's guardian, Leopold Czihaczek,
 ca. 1913.

one who has the understanding for the unusual, and I will explain
this misunderstanding to him.

My arrest is no misunderstanding!

I was not arrested because of the hysterical female, but rather—
and I suspect as a result of the accusation of my guardian—because
of a suspicion of lewdness with children, little girls, because of
the production of erotic—that is, obscene—drawings which I am
supposed to have shown to children or at least which, negligently,
I am supposed to have left lying about. Now at last I know why I
am "sitting" here! It is a scandal! An almost unbelievable crudity!
Vulgarity! And a great, great stupidity!

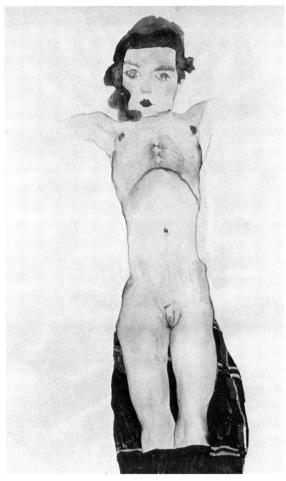

21. Schiele, *Standing Nude*, 1911, ink and
watercolor.

It is a cultural blasphemy, a shame for Austria that such a thing
can happen to an artist in his own country.

I do not deny it: I have made drawings and watercolors that are
erotic. But they are still always works of art—that I can attest, and
people who understand something of this will gladly affirm it.
Have other artists made no erotic pictures? Rops,* for example,
made only such kinds. But one has never imprisoned an artist for

* Félicien Rops, Belgian-French painter, engraver, and lithographer (1833–98).

this. No erotic work of art is filth if it is artistically significant; it is only turned into filth through the beholder if he is filthy. I could mention the names of many, many famous artists, even that of Klimt, but I do not want to excuse myself by this at all—that would not be worthy of me. Therefore I do not deny it. I do declare as untrue, however, that I showed such drawings intentionally to children, that I corrupted children. That is untrue! Nevertheless I know that there are many children who are corrupted. But then, what does it actually mean: corrupted? Have adults forgotten how corrupted, that is, incited and aroused by the sex impulse they themselves were as children? Have they forgotten how the frightful passion burned and tortured them while they were still children? I have not forgotten, for I suffered terribly under it.

And I believe that man must suffer from sexual torture as long as he is capable of sexual feelings.

Ah! How much is becoming clear to me now! The house search! The seizure of my papers! How stupid, how trusting I was! Two came. They looked like men. Colorful clothes. Glittering buttons. They approached, spoke, pointed; however, I never saw their faces, I found only masks; greed and stupid spite, mental laziness and maliciousness looked out cunningly from the small, slitted eye holes. And voices as though from a scratched gramophone, without vibration, without the slightest resonance of soul. Products of impure origin, without attempt at refinement, completely yoked to drive and drill, unfree. Creatures of evil demons. The skin on my back prickled with cold fear of the nearby animal odors. A solar eclipse darkened my soul and I was tired and ill with the thought that I should have to make myself comprehensible to the two police officers. Suddenly everything around smelled rotten, mossy, like a cellar.

Unexpectedly the two policemen—one constable and one municipal officer—pressed their way into my atelier in order to have a look at what I really do. The parents of some children whom I had drawn were worried. Someone had whispered this "worry" into their ears. The two spies found nothing objectionable in the atelier, but a picture that I had thumbtacked to my bedroom wall —a watercolor created in Krumau—they declared had to be confiscated as "suspicious." This seemed silly to me and annoyed me. I told both of them that there was nothing bad about that picture and that I had hung much more erotic things in a public art exhibition in Prague, where they, it is true, later had to be removed by police order. The constables asked if I still had these pictures from Prague and I answered that I did. Very self-righteous and smirking, the trapper requested: "Go on, give us a look at that stuff." I fell into the trap. I took the drawings out of the drawer where they lay and stupidly placed them in the sausage-like fingers of the two fellows. After both had looked at the entire pile, drawing by drawing, naturally, the constable announced in a severe voice: "These drawings are indecent. I will have to bring them to court. You'll be hearing from us further."

I heard nothing—but lock me up they did, the scoundrels.

They can—oh, yes, I understand now that they can, but I do not comprehend that they may—deprive a human being of his freedom, lock up a free artist—a person about whom it is not known whether or not he did that of which he is accused. On an accusation, or even worse, on a perhaps malicious or carelessly stupid complaint. That is robbery. Yes, the words "deprivation of freedom" have a vile meaning in reality.

I absolutely do not understand how I could have been locked up, how I could have remained locked up for more than a few hours.

22. Summons of arrest served on Schiele.

I do not understand how it has happened and I do not understand
why it has happened. I have not corrupted children, for I did not
show them these pictures, and as for adults, they know these
things very well anyway. Why, then? I am not at all an evil man!
I have not ravished, stolen, murdered, set fires—nor in any other
way offended the sensitive human "society"—except by my exist-
ence.

————————

There is good will in me—but what kind of will is there in others?
That remains to be seen. To be in control, to be ready to endure
all that life brings, is a self-evident duty. Only the transevaluation
and the utilization of experience is important. Determination not
to succumb.

Interrogations. Very strange. Very confusing. Sometimes frighten-

ing. Questions whose pertinence remains dark to me. Friendliness which I mistrust.

The "proceedings" concerning the "abduction" have long since been discontinued; the inquiry concerning the "pornographic pictures" goes on, however. Was it necessary to imprison me for that? Did the court fear that I would run away? Too stupid! Soon the hearing will take place. Well, they certainly are not going to castrate me, and they can not do that to art either. What, then, can actually happen to me? (Only that which is happening to me, which is evil and in any case unjust.)

Vienna, 8 May 1912

For 24 days I was under arrest! Twenty-four days or five hundred and seventy-six hours! An eternity!

The investigation ran its wretched course. But I have miserably borne unspeakable things. I am terribly punished without punishment.

At the hearing one of my confiscated drawings, the one that had hung in my bedroom, was solemnly burned over a candle flame by the judge in his robes! Auto-da-fé! Savonarola! Inquisition! Middle Ages! Castration, hypocrisy! Go then to the museums and cut up the greatest works of art into little pieces. He who denies sex is a filthy person who smears in the lowest way his own parents who have begotten him.

<u>Anyone who has not suffered as I have—how ashamed he will have to feel before me from now on!</u>

Color Plates

I. *The Single Orange Was the Only Light*

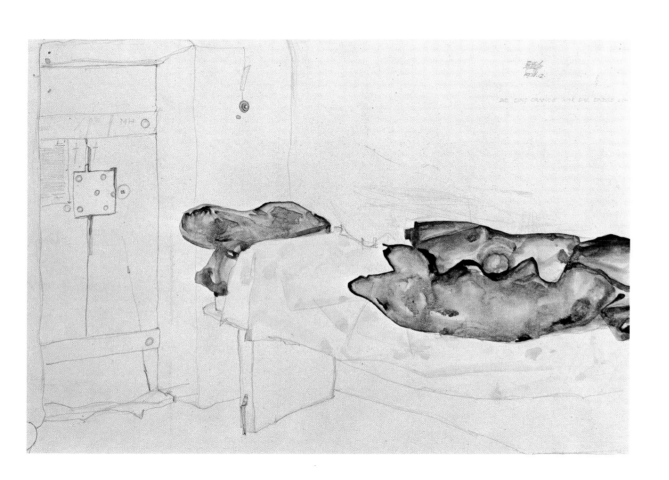

II. *I Feel Not Punished But Purified!*

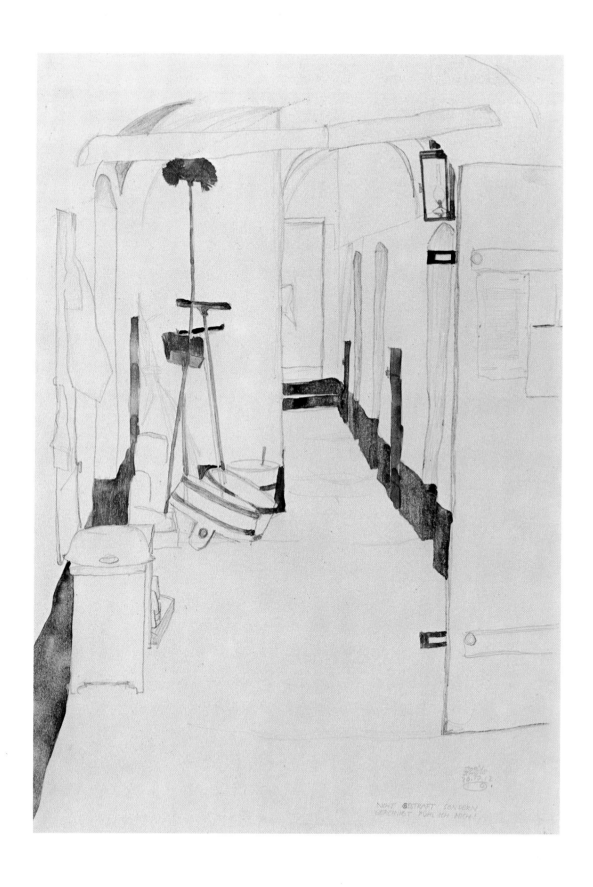

III. *The Door into the Open!*

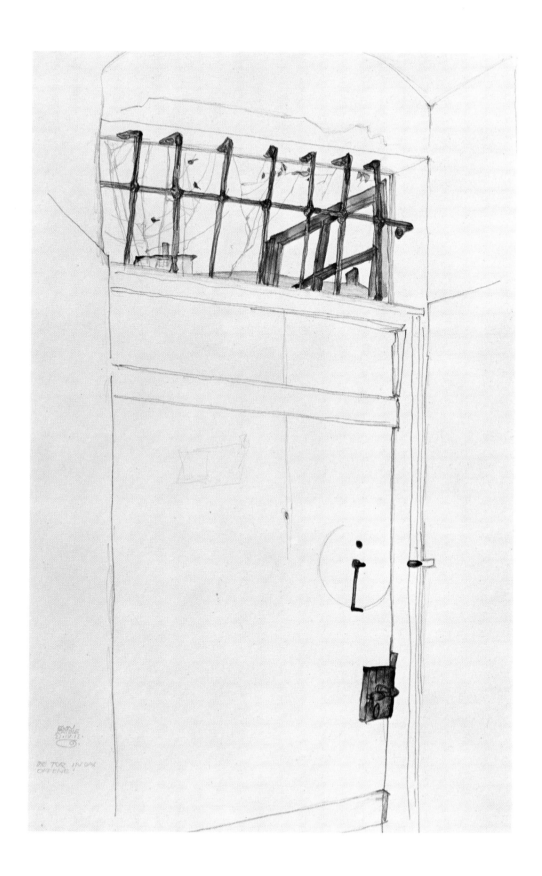

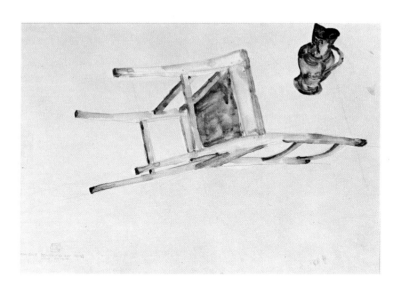

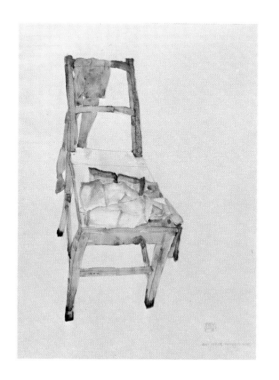

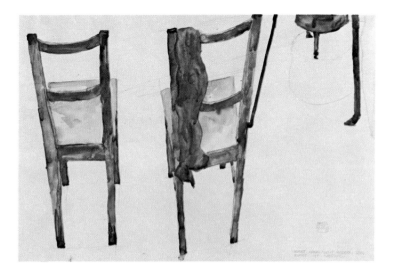

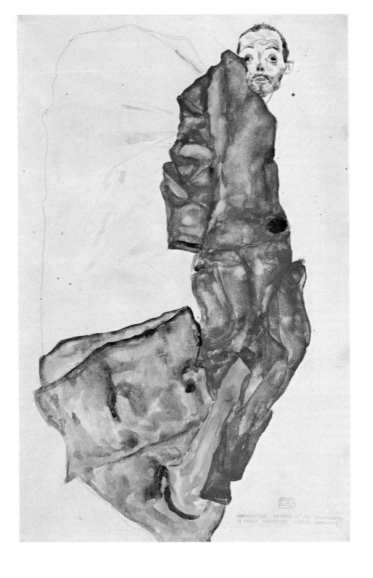

VII. *Hindering the Artist Is a Crime, It Is Murdering Life in the Bud!*

VIII. *I Love Antitheses*

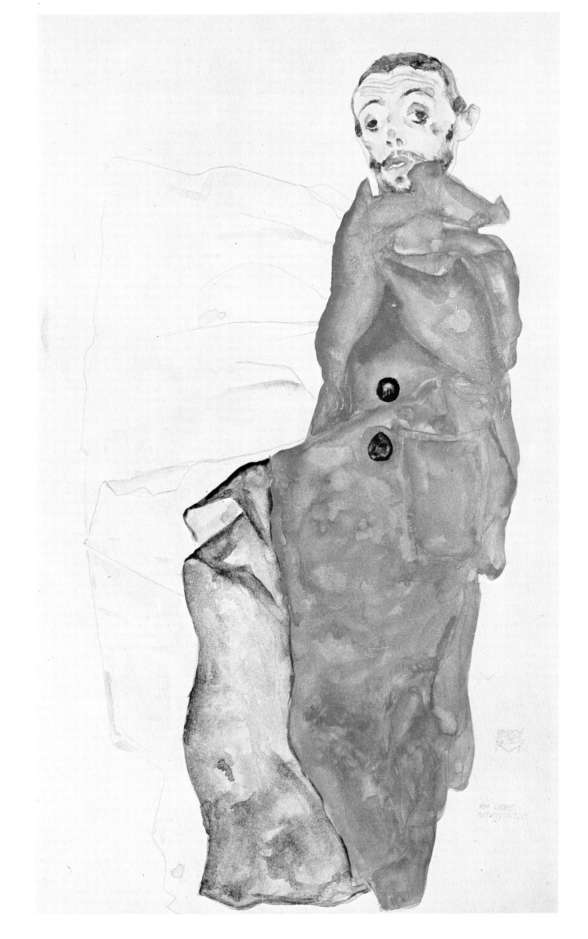

IX. *Prisoner!*

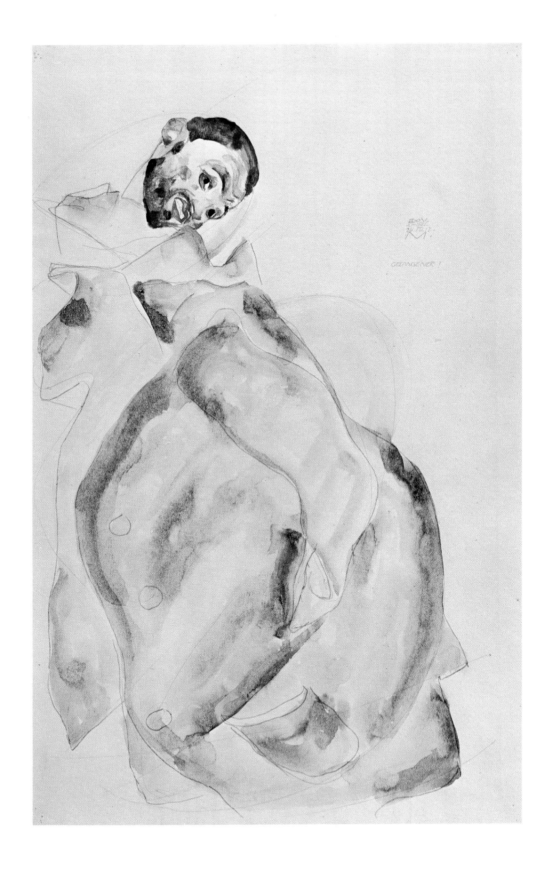

X. *For My Art and for My Loved Ones I Will Gladly Endure to the End!*

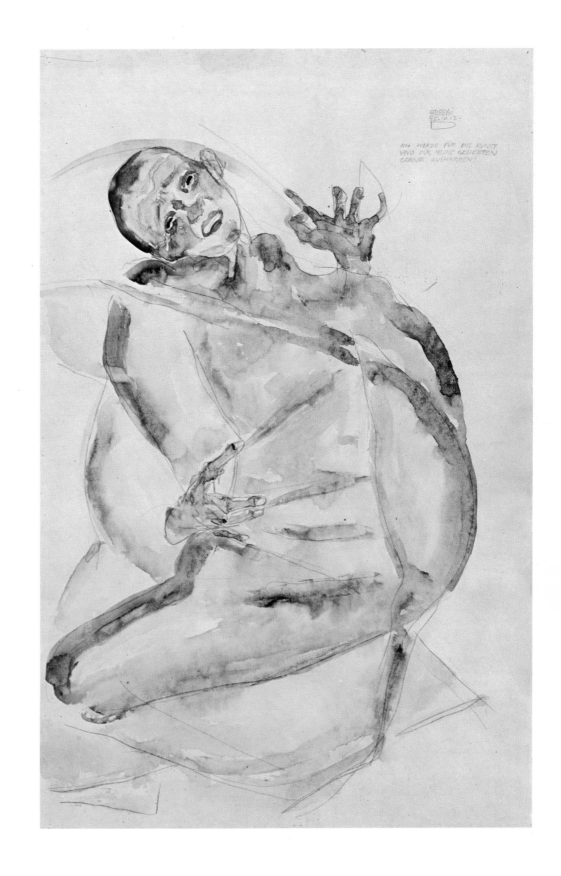

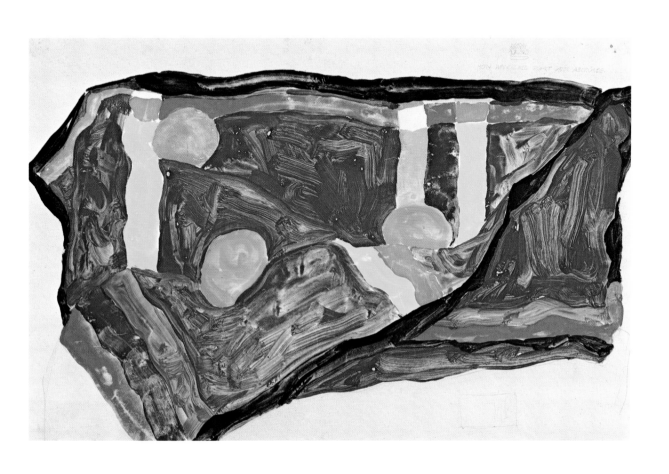

Commentary

Schiele wrote entries in a makeshift diary, did some drawings, and created at least thirteen watercolors during his imprisonment at Neulengbach. Twelve of these watercolors were signed, dated, and inscribed with aphoristic titles by the artist while still in prison. Examined alongside the diary, which refers to most of them by title, they present an extraordinary record of an experience in which drawing, the staple of Schiele's art, became his moral support as the artist struggled to understand, accept, and bear his imprisonment. We can follow day by day, in words and pictures, the prisoner's alternating moods of fortitude and despair.

In order to endure the hours of uncertainty during the first days in his cramped and gloomy basement cell, Schiele tried to smear the contours of heads and landscapes on the wall with his own spittle:

> And then I watched as little by little they dried up, faded and disappeared into the depths of the masonry, as if wiped out by an invisible, magically powerful hand.

After repeated entreaties he was allowed some paper and drawing materials, and, momentarily elated, he burst out:

> At last! At last! At last! At last alleviation of pain! At last paper, pencils, brush, colors for drawing and writing.

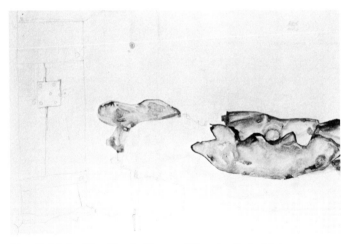

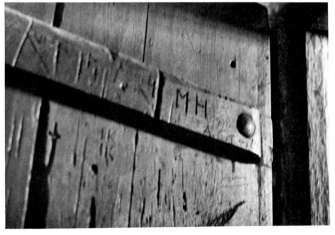

23. Schiele, *The Single Orange Was the Only Light,*
19 April 1912, pencil and watercolor.

24. The door of Schiele's cell, Neulengbach.

Then, more soberly, "I can be busy, and so I will endure what otherwise would be unendurable."

In his diary entry of 17 April, Schiele professed ignorance of the charges against him:

> . . . on 13 April 1912 I was arrested and put under lock and key in the Neulengbach district courthouse. Why? Why? Why? I do not know. To my question no answer was given.

Two days later, 19 April, he completed his first watercolor and described it with pleasure:

> I have painted the cot in my cell. In the middle of the dirty gray of the blankets a glowing orange, which V[ally] brought me, as the single shining light in the room. The little colorful spot did me unspeakable good.

Schiele's picture (color pl. I) shows a narrow low-ceilinged room with thick walls converging toward a heavy wooden door bound by two horizontal bands of wood. An iron grate covers the hole through which food was passed. The bed is a plank set on blocks of wood. Schiele's coat is folded to make a pillow, and on top of the crumpled blanket, painted in blues, browns, and grays, glows the bright orange that his mistress Vally had brought to comfort him. Schiele's ravenous eyes consumed all features of the small cell, and he recorded every detail. The initials "M H", carved by

some former prisoner on the upper horizontal band of the cell door, and visible there to this day, are clearly shown in the watercolor. On the wall above the bed Schiele has indicated, in very light lines, one of the little landscapes he painted with his own spittle before he received drawing material. Above this he printed his name. Beneath it he printed a large capital "G" for *Gefängnis* (prison) and the watercolor's title in block letters: THE SINGLE ORANGE WAS THE ONLY LIGHT.

Schiele wrote in his diary that the guard made him wash the floor of his filthy cell and that, elated at having something to do, he meticulously scrubbed every inch of the floor and waited impatiently for the guard's re-action. The guard spat on the floor, cursed him, and ordered him to do it again. There is, therefore, genuine sarcasm in the pompous title of Schiele's watercolor done the next day, 20 April (color pl. II): I FEEL NOT PUN-ISHED BUT PURIFIED! Diary and watercolor bear this out:

> *20 April 1912*
> Drew the corridor before the cells, with the rubbish that lies in the corners and the equipment used by the prisoners to clean their cells. Fine. Gave me equilibrium. I feel not punished but purified!

With the same fidelity to fact which occurs in the painting of the cell, the second watercolor corresponds exactly with the corridor as it still exists. To draw the scene, Schiele must have been allowed to leave his cell and to work in the corridor itself. On the right is the door to Schiele's cell, "No. 2", which is swung open into the corridor. Color has been applied to this draw-ing sparsely but with striking effect. In the real hall and in that in the picture a gray band of paint runs along the walls at floor level. Schiele's ability to transform this dismal space is admirable. Tipped with yellow and olive greens, the clumsy mops assume a slender dignity of great pictorial interest. Without swerving from reality Schiele has created a drawing of intriguing composition and effect.

As Schiele drew this picture his back was to a heavy wooden door that led directly to the outside world. The following day, 21 April, he drew this door (color pl. III). The drawing is a grave and beautiful one, rich with sug-gestions of the meaning of freedom. Above the thick door is an iron grating, similar to the one in Schiele's cell. The window beyond the grate is swung open. The view through the bars is excruciating in its hint and denial of freedom. Familiar objects of the outside world can be distinguished: the gray roof and chimney of a house and the bare branches of a tree, pale and

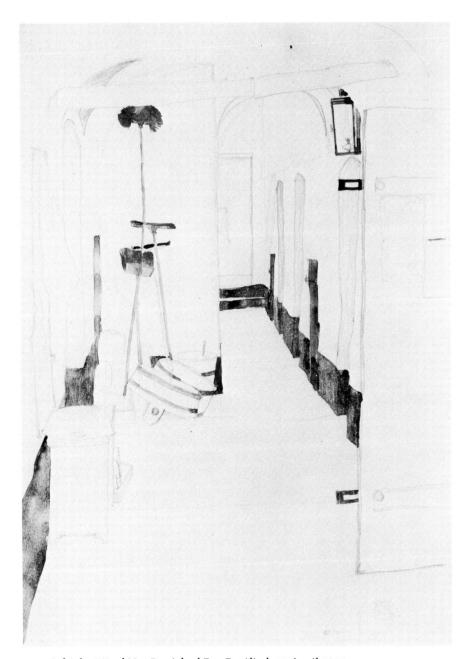

25. Schiele, *I Feel Not Punished But Purified*, 20 April 1912.

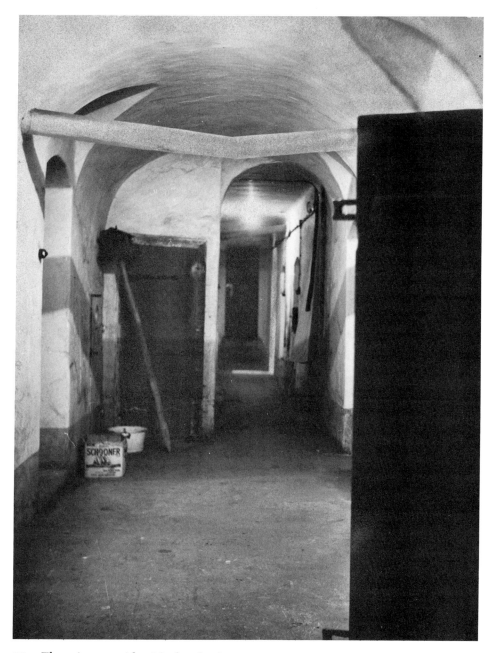

26. The prison corridor, Neulengbach.

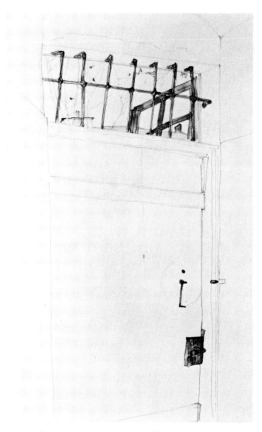

27. Schiele, *The Door into the Open!* 21 April
1912, pencil and watercolor.

illusionary behind the dark reality of the bars. In the nearer branches a few
yellow buds speak of spring. Farther back three tiny specks of gray represent
birds that have perched momentarily before taking flight. The physical
signs of confinement—the grill and its window, the two locks—are painted
grayish blue and stand in bitter contrast to the penciled doorway and pale
exterior world. The superfluous door hook has beveled into the wood the
circumference of its swing as though in mockery of the prisoner's own
limited radius. The drawing is titled: THE DOOR INTO THE OPEN! There
can be little doubt that in this, as well as in the preceding watercolor of the
corridor, Schiele was thinking of Van Gogh's hospital interiors painted at
the asylum in Saint-Rémy twenty-three years earlier.

That same day, 21 April, Schiele was apparently again confined to his
cell and had to content himself with things that he had not yet depicted in

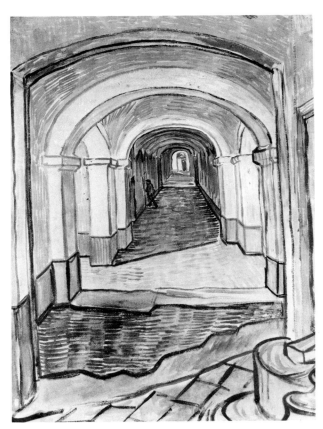

28. Vincent Van Gogh, *Hospital Corridor
at Saint-Rémy*, 1889–90, gouache and
watercolor.

29. The prison corridor looking toward
"the door into the open,"
Neulengbach.

the narrow, dark enclosure. Except for his own clothing, he had only a chair and a water pitcher as objects to study. Nevertheless he created three unusual still-life watercolors. He wrote:

21 April 1912

The imprisonment has become more bearable since I have been able to work. I have drawn the organic movement of the primitive chair and water pitcher, and lightly applied colors to the drawing. I also drew two of my colored handkerchiefs in combination with the chair.

The watercolors are entitled: REMEMBRANCE OF THE GREEN STOCKINGS (shown herein only in black and white),[1] ORGANIC MOVEMENT OF THE CHAIR AND PITCHER (color pl. IV), and TWO OF MY HANDKERCHIEFS (color pl. V). In this series of drawings Schiele progressively challenged his artistic energy with technical problems. The hermetic confrontation of the two objects—stockings and chair—against a void in REMEMBRANCE OF THE GREEN STOCKINGS becomes converted into an active dialogue between space and two images from reality in ORGANIC MOVEMENT OF THE CHAIR AND PITCHER, producing much the same expressive dislocation and existential force that is characteristic of Expressionist portraiture. Now the chair is shown from the side and from below. Faint pencil lines indicate the swirling circumferences of the water pitcher, and the contrary thrusts of the vertical and horizontal members of the chair. In TWO OF MY HANDKERCHIEFS Schiele stood to one side and looked down upon the chair. He has unfolded and arranged two handkerchiefs on the seat, so that the creases dip and rise. Over the back of the chair are hung the long green stockings, and their color initiates a simple descending chord of green, blue, and yellow material against the light blue, greens, and browns of the chair. Such compositional intensity reflects the discipline invented and imposed upon himself by the artist to hold his attention and keep despair at bay. All three watercolors bear the capital "G" for Gefängnis.

The next day Schiele was noticeably less self-sufficient. To the still-life study of that day, 22 April, he gave the rather grandiose title ART CAN NOT BE MODERN: ART IS PRIMORDIALLY ETERNAL (color pl. VI). The humbleness of the chair, drawn twice in this picture, and the plainness of the bucket and the other, few objects in his cell have begun to depress him. He can no longer accept them as simple objects. He bathes them in blues

Above, right: 30. Schiele, *Remembrance of the Green Stockings,* 21 April 1912, pencil and watercolor.

Below, left: 31. Schiele, *Organic Movement of the Chair and Pitcher,* 21 April 1912, pencil and watercolor.

Below, right: 32. Schiele, *Two of My Handkerchiefs,* 21 April 1912, pencil and watercolor.

33. Schiele, *Art Can Not Be Modern: Art Is Primordially Eternal,* 22 April 1912, pencil and watercolor.

and light greens, but still they disappoint him. He feels a need to bestow on them some sort of meaning—he, an artist, must not be reduced to the repetitious rendition of chance objects! That day he wrote in his diary:

> *22 April 1912*
> Primordially eternal is God. Man calls him Buddha, Zoroaster, Osiris, Zeus, or Christ, and timeless like God is that which is most Godlike after him, art. Art can not be modern; art is primordially eternal.

On 23 April, inanimate objects no longer hold Schiele's attention. They are not sufficient to distract his growing despair. The God to whom he afforded only titular reference the day before now becomes the center of his thoughts. Has he been forgotten by this God? Schiele, who had had little use for the Catholic God of his childhood days, is now compelled to call upon him—if he is there:

> *23 April 1912*
> Look down here, universal Father . . . and consider whether you wish to tolerate that this shameful debasing torture is being prepared for me. . . .
> But to suffer through your will? To be imprisoned through your will? Am I?

Schiele now tries to attract the attention of this God he has addressed in the diary. In an almost atavistic gesture he presents himself as a votive offering—he paints a self-portrait (color pl. VII). It is a pitiable creature that he portrays, one incapable even of resistance to suffering. Lying motionless upon his narrow cot, a coat thrown over his long frame, he turns his head feebly to one side, revealing an unshaven, hollow-eyed countenance. The hands, so important in Schiele's art when he wishes to convey emotion, are lacking—a symbol of his impotence in this situation. The great overcoat is painted a stifling orange with two large blue buttons down the front. Yellow cloth is under his legs and at his feet is the gray prison blanket. He has signed and titled the picture at the bottom right, requiring a vertical reading that produces a distinct shock in the beholder, since the figure now appears not recumbent but uneasily erect, as though pinned to some rack of torture. The title is a reproach both to profane and to divine authority: HINDERING THE ARTIST IS A CRIME, IT IS MURDERING LIFE IN THE BUD! Corresponding to the change in subject matter from surroundings to self, the decorative capital letter that appears underneath the date in the first of the prison series changes from the "G" for *Gefängnis* (prison) to a "D" for

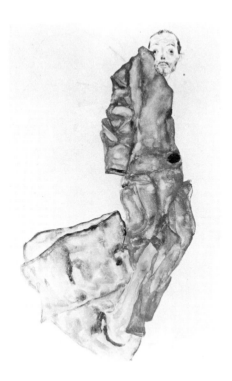

34. Schiele, *Hindering the Artist Is a Crime, It Is Murdering Life in the Bud!*, 23 April 1912, pencil and watercolor.

Dienstag (Tuesday)—that is, from where to when. This concern for the exact day of the week continues for the rest of the series except for the final picture.

The next day Schiele turned his thoughts toward a very real being, the authority who had placed him in jail. In his diary he mused:

> *24 April 1912*
> Not very far from me, so near that he would have to hear my voice if I were to shout, there sits in his magistrate's office a judge, or whatever he is. A man, that is, who believes that he is something special, who has studied, who has lived in the city, who has visited churches, museums, theaters, concerts, yes, probably even art exhibitions. A man who consequently is numbered among the educated class which has read or at least heard of the life of the artist. And this man can permit me to be locked up in a cage!

Schiele was closer to the truth than he could possibly have imagined when he assumed that the magistrate in charge of his case was an educated man of culture. The judge, a certain Dr. Stovel, who eventually passed sentence on Schiele and who shocked the courtroom by setting fire to one of the artist's drawings, actually possessed a great interest in art; unfortunately not the sort of art produced by the young "offender" brought before his bench. Stovel was an avid collector of the paintings and drawings of the Austrian Jesuit artist Franz Stecher (1814–53), who had decorated Jesuit churches in the United States as well as in Austria. This artist was mentally unbalanced, and his paintings reveal a morbid pornographic mingling of religious and sexual elements, done in a feeble neo-Blake style. Thus the judge who condemned Schiele for his undisguised erotic art was himself a collector of erotic art in a more "acceptable" form. In this respect Stovel displayed the neurotic obsession with the erotic in permissible disguises which was part of the overrefined sensualism of the pre-World War I culture of Vienna.[2]

In the first watercolor made on 24 April (color pl. VIII), Schiele again portrayed himself. On the planks that form his cot, he now appears lying on his side with his legs drawn up underneath the blanket and coat, seeking warmth against the chilly April weather and the perpetual dampness of his basement cell. His coat is colored an oppressive orange-red and the two buttons on it are almost offensive in their cheerful commonplaceness and great size. Together with the effect of the formless drapery they help to

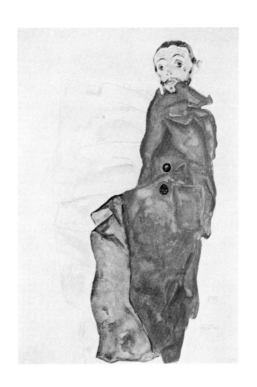

35. Schiele, *I Love Antitheses,* 24 April
1912, pencil and watercolor.

suggest the incongruous aspect of a clown. The hands are still pressed out
of sight. Once again the picture is signed to require a vertical reading. The
decorative letter is now an "M" (*Mittwoch*—Wednesday) and the title says
bitterly: I LOVE ANTITHESES.

But the suffering reflected in the first self-portrait and the humorless
sarcasm presented in the second drawing of himself still did not bring a
response from the fellow human beings who controlled Schiele's fate. There
was no answer to his call, and we know that he did call aloud:

> *25 April 1912*
> Yesterday: cries—soft, timid, wailing; screams—loud, urgent, im-
> ploring; groaning sobs—desperate, fearfully desperate. Finally
> apathetic stretching out with cold limbs, deathly afraid, bathed in
> shivering sweat.

Only one picture, one word, can describe Schiele's condition on that previ-
ous day, 24 April: PRISONER! (color pl. IX). We see him stretched out full
length, his body seized by paroxysms and the red lips drawn back over his
chattering teeth in a hideous grin of seeming insanity. His head snaps for-

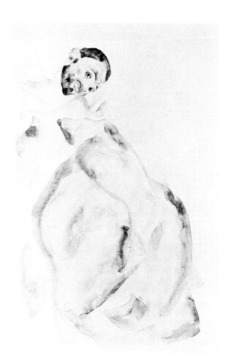

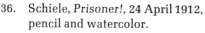

36. Schiele, *Prisoner!*, 24 April 1912, pencil and watercolor.

37. Schiele, *For My Art and for My Loved Ones I Will Gladly Endure to the End!*, 25 April 1912, pencil and watercolor.

ward as though broken at the neck. Hair and beard are uncared-for. The great overcoat writhes in response to his convulsions, the empty sleeve flaps aimlessly. Suffering appears to have dulled his brain; it is a mindless body that churns in anguish. Here is a being who has cried out, a man who has shrieked in agony and then fallen into apathy.

"And yet," wrote Schiele, continuing his diary next day, "for my art and for my loved ones I will gladly endure to the end." This statement becomes the title of a self-portrait painted on 25 April and marked "D" (*Donnerstag*—Thursday) (color pl. X). The title announces a change in Schiele's vision of himself. He has made the decision that he can last out, that he can survive this cruel confinement. Now he can suffer, now he can unashamedly voice his agonies. For the first and only time in this row of four self-portraits Schiele shows his hands. They are claws, flailing empty space, clutching at his blanket—so hard that the fingers send creases shooting across the fabric. The reappearance of the hands as symbols of suffering is a gesture of return to the living. Schiele has cut his hair and beard. He shows himself full face, with his head thrown back. His distress is great, but he will experience it

38. Detail of fig. 37.

as a conscious human being, not as the benumbed creature of the previous self-portrayals. He has sworn to endure for the sake of his art and for his loved ones. With this decision, the need to depict himself as a suffering prisoner is appeased, for this is the last self-portrait of the Neulengbach series.

Schiele's decision appears to have given him strength and enthusiasm: he now painted with a new fervor and a new approach. On 27 April he wrote: "What would I do now if I did not have art? . . . I love life. I love to sink into the depths of all living beings." This desire to "sink into the depths" is observable in the watercolor produced that day: MY WAN-DERING PATH LEADS OVER ABYSSES (color pl. XI). The picture is an astonishing contrast to the previous drawings. Schiele has abandoned con-templation of himself and, hungry for outward sights, he has pounced upon the simple study of three oranges placed upon his bed. This is no exact rendition of nature; the subject matter is transformed. The dull gray of the blanket has been converted into a rich brown rimmed in vigorous black, and is crossed by stripes of yellow, red, blue, light brown, and white. Color

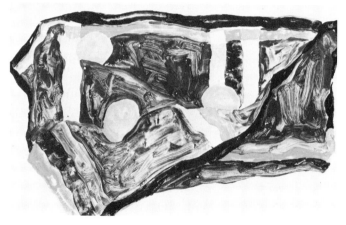

39.　Schiele, *My Wandering Path Leads over Abysses,*
　　27 April 1912, pencil and watercolor.

is relieved of its form-defining function and overrides the objects. A pre-
paratory drawing for this watercolor was entitled by Schiele: ALL THINGS
BALANCE OUT PHYSICALLY MOST SURELY (fig. 40).[3] In the final water-
color the three glowing balls of orange are shown in relation to a brilliant
patchwork cosmos. In the abstract proportions of this cosmos Schiele could
read and symbolize the precipitous course of his own life.

The salutary effect of Schiele's new objectivity and use of robust color-
ing is apparent in the thirteenth and final watercolor of the Neulengbach
prison series (shown herein only in black and white). On the first day of
May he recorded in his diary:

> I dreamt of Trieste, of the sea, of open space. Longing, oh, long-
> ing! For comfort I painted myself a ship, colorful and big-bellied,
> like those that rock back and forth on the Adriatic. In it longing
> and phantasy can sail over the sea, far out to distant islands where
> jewel-like birds glide and sing among incredible trees.

This beautiful watercolor of a Trieste fishing boat, done completely from
memory, represents a rare departure from Schiele's method of working
directly from nature.[4] He has painted something real, but to do so he had
to depart from reality, from the oppressiveness of his surroundings. The
perfection of detail, the vibrant sense of presence, and the shimmering
colors give triumphant proof of the dimension and intactness of Schiele's
artistic powers during the Neulengbach confinement.

40. Schiele, *All Things Balance out Physically Most Surely*, 26 April 1912, pencil.

41. Schiele, *Trieste Fishing Boat*, 1912, pencil and watercolor.

In his prison diary Schiele had gloomily speculated on what the charges against him might be:

> *29 April 1912*
> If only I knew why they have stuck me in here. It could not have happened because of the drawing. Or could it? In Austria anything is possible. Here, where Waldmüller had to write the tax office a beggar's letter, where Romako was driven to suicide by the lack of understanding and the jealous envy of incompetents, where university professors sneered at Klimt in the most shameful, self-tainting way.

This calling to mind of previous artists who had suffered at the hands of society seems to have comforted Schiele, and a walk in the prison courtyard at St. Pölten with the other inmates prompted him to recall yet another artist:

> *Another day, a May day!*
> A walk in the prison courtyard. Roller is surely a great artist, but his prison yard in *Fidelio* is still only theater, whereas the painting of the prison courtyard by Van Gogh is the most stirring truth, great art.

Just as earlier, when he had been happy in Neulengbach and painted a paraphrase of *Bedroom at Arles* in homage to Van Gogh, so now, in a period of depression, Schiele turned again to the Dutch artist for inspiration. The comparison of Van Gogh's "real" prison courtyard (based on Doré) with Alfred Roller's "stage" courtyard indicates Schiele's awareness of events in the Viennese opera world. Roller's imaginative sets for Gustav Mahler's new production of *Fidelio* in 1904 were still highly admired and had recently received praise from the eminent critic Hermann Bahr, who referred to Roller's prison backdrops as "heroic realism." Actual imprisonment had only sharpened Schiele's ability to distinguish the "stirring truth" of the Dutch painter from the "heroic" reality of the Viennese set-designer. It is no wonder that he felt close to Van Gogh once again. Here one recalls that throughout his life Schiele was heard to remark occasionally that he wished he had a brother to help him as Theo Van Gogh had helped Vincent.

When Schiele finally learned that one of the charges for which he was

to be brought to trial would be based on his confiscated erotic drawings, he again recalled other artists, exploding indignantly to his diary:

> It is a scandal! An almost unbelievable crudity! Vulgarity! And a great, great stupidity! It is a cultural blasphemy, a shame for Austria that such a thing can happen to an artist in his own country. I do not deny it: I have made drawings and watercolors that are erotic. But they are still always works of art—that I can attest, and people who understand something of this will gladly affirm it. Have other artists made no erotic pictures? Rops, for example,

42. Félicien Rops, *Summer.*

made only such kinds. But one has never imprisoned an artist for this. . . . I could mention the names of many, many famous artists, even that of Klimt, but I do not want to excuse myself by this at all—that would not be worthy of me.

43. Gustav Klimt, *Reclining Nude with Drapery*, blue crayon.

With this kind of reasoning, based on an established tradition of the freedom of great artists to produce erotic art, Schiele attempted to console himself. Moreover, with his confidence in his status as an artist, his belief in artistic privilege, he revolted at the thought of legal prosecution involving works of art.

The thirteen Neulengbach watercolors are a visual record of how Schiele was able to sublimate through art his suffering in prison. They document the artist's reactions concerning first his imprisonment, then himself, and finally his art in relation to the world. The watercolors are divisible into three corresponding groups. The first seven deal with the prisoner's immediate surroundings—the cell, corridor, and "door into the open," and with objects near him—the chair, the water pitcher, and his own clothing. All seven pictures are based directly on factual objects, with meticulous veracity of detail. Before Schiele was permitted to have drawing materials he tried to paint landscapes and heads on the cell walls with his own spittle. But as soon as he obtained pencil, paints, and paper this type of inventive drawing was displaced by his habitual method of working directly from nature. Seven drawings later, and despite an attempt to infuse his humble subject matter with symbolic value (ART CAN NOT BE MODERN: ART IS PRIMORDIALLY ETERNAL), Schiele could no longer bear to record the gloomy reality of his surroundings. His thoughts turned inward, upon a vision of himself as a victim of injustice, and in three consecutive days he made four self-portraits. For perhaps the first time in his life he portrayed himself without reference to a mirror image. Contemplation of self when undistracted by a physical reflection reached new depths of introspection. The helpless suffering of HINDERING THE ARTIST IS A CRIME, IT IS MURDERING LIFE IN THE BUD! is followed by the bitter I LOVE ANTITHESES, the false bravado of which is then pierced by the desperate cry, PRISONER! The last self-portrait reveals a dramatic change in the artist's conception of himself: FOR MY ART AND FOR MY LOVED ONES I WILL GLADLY ENDURE TO THE END! The third group of Neulengbach watercolors exhibits fresh dimensions of Schiele's artistic resources: he first

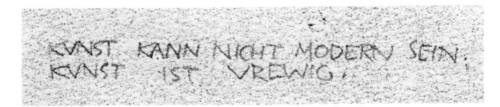

44. Detail of fig. 33.

transforms reality (MY WANDERING PATH LEADS OVER ABYSSES), then draws upon the world of memory and phantasy for his motifs (*Trieste Fishing Boat*). This capacity for adjustment demonstrates how Schiele was able, in fact, to "endure to the end" his Neulengbach imprisonment.

The charges against Schiele were "immorality" and "seduction," and yet at the trial it was *as an artist* that he was condemned and publicly disgraced. The spectacle of watching one of his own works deliberately set aflame in open court seared his memory. Shattered and humiliated, he shied away from discussing the incident with his friends. Schiele's belief

45. Schiele, *Woman in Mourning*, K. 154, 1912, oil.

in the infallibility of the artist had been based on an aesthetic individualism. In a course that in many ways parallels that of another firm and tragic believer in the aesthetic imperative, Stefan George, Schiele chose in the face of shattering reality to dissociate himself by retreating into a proud isolationism from which he hurled symbolic darts at the world. Embracing the role of social outcast and craving sympathy, he set down for himself a permanent lamentation, the double portrait *Woman in Mourning* (fig. 45). The woman is the artist's faithful Vally, her features stamped with grief. Comparison of this portrait with an earlier, lyrical study of Vally (fig. 46)

46. Schiele, *Portrait Sketch of Vally,*
1911, pencil.

demonstrates by what simple means the artist was able to imprint his own suffering upon the familiar features of his sorrowing companion, who had attempted in a small way to alleviate the gloom of his prison cell. Vally's usually straight bangs curl in unheeded disarray, a skeletal emaciation is suggested by the fall of the scarf about the face, and the dark pupils of the great eyes are moist with compassion. As an incarnation of Vally's distressed thoughts there projects behind and beyond her head to the left a pale profile—the features are unmistakably those of Schiele. He presents himself as a suffering counterpart to his melancholy beloved. To the extreme left a single sunflower from which all but a few petals have been plucked stands as a reminder of the artist's own recent spiritual mutilation.

The terrible fact of his imprisonment and trial weighed long upon Schiele's mind. The self-portraits of the next few years would trace a painful and fragile rehabilitation of the artist's image of himself via the antisocial

47. Schiele, *Self-Portrait as St. Sebastian*, 1914, pencil.

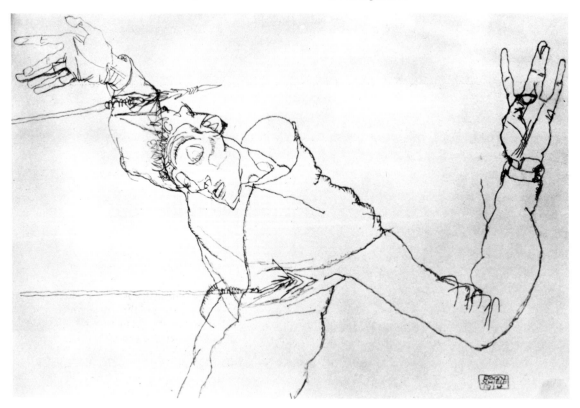

guises of hermit and monk. Before Schiele could rejoin the world that had persecuted him, he had to complete a cycle of identification with suffering by presenting himself to that world as a martyr. In an eloquent study for a poster announcing a one-man exhibition of his works, scheduled to open in December of 1914, Schiele showed himself as St. Sebastian (fig. 47). We see a limp figure, the arms outstretched, the head hanging forward on a fragile neck, the eyes bulging, and the mouth open. Two arrows penetrate the body, and the fingers are rigidly spread in an expression of pain. Still tormented by the memory of his imprisonment, Schiele here seems to repeat almost accusingly the concluding words of his prison diary:

Anyone who has not suffered as I have—how ashamed he will have to feel before me from now on!

Notes

1. This and the other watercolors in the series are all of approximately the same size, 9 x 17 inches.

2. For this fascinating information on the personality of the judge who passed sentence upon Schiele, I am grateful to the late Dr. Otto Benesch, whose father Heinrich visited Schiele in prison. For an idea of the kind of art preferred by this judge, see Martha Reinhardt, *Franz Stecher* (Vienna, 1957).

3. This preparatory drawing—the only known study for the prison watercolors—is dated 26 April 1912 with an "F" (*Freitag*—Friday) and bears the printed title PHYSI-KALISCH GLEICHT SICH ALLES AM SICHERSTEN AUS (Galerie St. Etienne,

New York; cf. my article "Egon Schiele in Prison," *Albertina Studien*, II, 4, 1964, illustrations 13 and 14). It is interesting to follow Schiele's change of mood from the objectivity recorded in the title for the drawing to the extreme emotion expressed in the title assigned to the watercolor painted the following day, 27 April 1912, with an "S" for *Samstag*—Saturday.

4. The watercolor illustrated here is the one reproduced by Arthur Roessler in his 1922 publication of the prison diary, and the one traditionally thought to be the work to which Schiele referred. Unlike the other twelve watercolors in the series, however, it does not bear an exact date and capital letter for place or day of the week, nor does it carry a special title.

List of Illustrations

Halftones

Frontispiece: Photograph of Egon Schiele, 1914. Courtesy of Melanie Schuster, Vienna

1. Photograph of the Neulengbach District Courthouse, Neulengbach, Austria. Comini, 1963

2. Caricature of Schiele's work: "This is really filthy!" Cartoon in unidentified Viennese newspaper sometime during the 1920's.

3. Schiele, *The Artist and His Model*, 1910, black chalk. Albertina Museum, Vienna

4. Schiele, *Reclining Woman with Upturned Skirt*, K.127, 1911, oil. Formerly Collection of Irene Beran, Brünn. Reproduced from *Egon Schiele: Oeuvre Catalogue of the Paintings* by Otto Kallir, © 1930 and 1966 by Otto Kallir and Paul Zsolnay Verlag Gesellschaft m.b.H.; used by permission of Crown Publishers, Inc.

5. Photograph of Schiele's rented garden house on the outskirts of Neulengbach. Comini, 1963

6. Photograph of Schiele and Valerie Neuzil, 1913. Courtesy of Melanie Schuster, Vienna

7. Vincent Van Gogh, *Bedroom at Arles,* 1888, oil. Courtesy of The Art Institute of Chicago

8. Schiele, *The Artist's Bedroom at Neulengbach,* K.149, 1911, oil. Historisches Museum der Stadt Wien, Vienna

9. Schiele, *Portrait Sketch of Heinrich Benesch,* 1913, pencil. Lambeth Arts Ltd., London

10. Photograph of Schiele, *ca.* 1912–13. Courtesy of Melanie Schuster, Vienna

11. Schiele, *Self-Portrait, ca.* 1911–12, pencil. Egon Schiele Archive, Albertina Museum, Vienna

12. Schiele, *Portrait of Arthur Roessler,* K.105, 1910, oil. Historisches Museum der Stadt Wien, Vienna

13. Photograph of Schiele and Arthur Roessler, 1913. Courtesy of Melanie Schuster, Vienna

14. Photograph of the Neulengbach prison from the rear, showing Schiele's cell window. Comini, 1963

15. Photograph of Schiele's prison cell window from the inside. Comini, 1963

16. Schiele, *Self-Portrait with Fingers Spread Apart,* K.124, 1911, oil. Historisches Museum der Stadt Wien, Vienna

17. Photograph of Gustav Klimt sometime during World War I.

18. Photograph of Anton ("Toni") Faistauer, 1905. Courtesy of Gertrud Peschka and Anton Peschka, Jr., Vienna

19. Photograph of Alfred Roller, *ca.* 1904. Courtesy of Adele Harms, Vienna

20. Photograph of Schiele's guardian, Leopold Czihaczek, *ca.* 1913. Courtesy of Melanie Schuster, Vienna

21. Schiele, *Standing Nude,* 1911, ink and watercolor. Helen Serger, La Boetie, Inc., New York

22. Summons of arrest served on Schiele. Courtesy of Dr. Otto Kallir, Galerie St. Etienne, New York. From *Egon Schiele: Oeuvre Catalogue of the Paintings* by Otto Kallir, © 1930 and 1966 by Otto Kallir and Paul Zsolnay Verlag Gesellschaft m.b.H.; used by permission of Crown Publishers, Inc.

23. Schiele, *The Single Orange Was the Only Light,* 19 April 1912, pencil and watercolor. Albertina Museum, Vienna

24. Photograph of the door of Schiele's cell, Neulengbach. Comini, 1963

25. Schiele, *I Feel Not Punished But Purified!,* 20 April 1912, pencil and watercolor. Albertina Museum, Vienna

26. Photograph of the prison corridor, Neulengbach. Comini, 1967

27. Schiele, *The Door into the Open!,* 21 April 1912, pencil and watercolor. Albertina Museum, Vienna

28. Vincent Van Gogh, *Hospital Corridor at Saint-Rémy,* 1889–90, gouache and watercolor. Collection The Museum of Modern Art, New York, Abby Aldrich Rockefeller Bequest

29. Photograph of the prison corridor looking toward "the door into the open," Neulengbach. Comini, 1967

30. Schiele, *Remembrance of the Green Stockings,* 21 April 1912, pencil and watercolor. Collection Gertrud Peschka and Anton Peschka, Jr., Vienna

Color Plates of Schiele's Prison Art

Works Cited

Benesch, Heinrich. *Mein Weg mit Egon Schiele.* New York, 1965.

Comini, Alessandra. "Egon Schiele in Prison," *Albertina Studien,* II, 4, 1964, pp. 123–37.

————. "Egon Schieles Kriegstagebuch 1916," *Albertina Studien,* IV, 2, 1966, pp. 86–102.

Kallir, Otto. *Egon Schiele, Oeuvre-Katalog der Gemälde.* Vienna, 1966.

Reinhardt, Martha. *Franz Stecher.* Vienna, 1957.

Roessler, Arthur. *Briefe und Prosa von Egon Schiele.* Vienna, 1921.

————. *Egon Schiele im Gefängnis.* Vienna, 1922.

————. *Erinnerungen an Egon Schiele.* 2nd ed. Vienna, 1948.